S0-BRD-037

DISCARD

OCT 18 2013

709.421 One

One thing leads to another.

PRICE: $19.95 (3559/he)

Published to accompany the project
One Thing Leads to Another—Everything is Connected
Jubilee line
July 2009–October 2011

Curated by Louise Coysh, Tamsin Dillon and Sally Shaw
Commissioned and produced by Art on the Underground,
with generous support from the National Lottery through
Arts Council England.

© 2012 Art on the Underground, London Underground Limited;
Black Dog Publishing Limited, London UK;
the artists and authors. All rights reserved.
All other texts written by Charlotte Bonham-Carter,
Louise Coysh and Sally Shaw.

Edited by Charlotte Bonham-Carter,
Louise Coysh and Tamsin Dillon
Copy edited by Melissa Larner
Designed by Rose
Endpapers: Claire Nichols, from the series
The Tacit Knowledge of the Underground, 2010

Black Dog Publishing Limited
10A Acton Street
London
WC1X 9NG
United Kingdom
Tel: +44 (0)20 7713 5097
Fax: +44 (0)20 7713 8682
info@blackdogonline.com
www.blackdogonline.com

No part of this publication may be reproduced, stored in a retrieval system, or
transmitted, in any form or by any means, electronic, mechanical, photocopying,
recording, or otherwise, without prior permission of the publisher.

Every effort has been made to trace the copyright holders, but if any have
been inadvertently overlooked the necessary arrangements will be made
at the first opportunity.

All opinions expressed within this publication are those of the authors and not
necessarily of the publisher.

British Library Cataloguing-in-Publication Data.

A CIP record for this book is available from the British Library.
ISBN: 9781907317897

Black Dog Publishing Limited, London, UK, is an environmentally responsible
company. This publication is printed on an FSC certified paper.

Image Credits
pp. 14, 15, 16, 19, 20, 21: copyright TfL, courtesy of
London Transport Museum
pp. 37, 40, 41, 42, 43, 53, 64, 70, 71: copyright
Daisy Hutchinson
pp. 44, 45: courtesy of TfL
p. 52: courtesy of the Disfarmer project at disfarmer.org,
from the collection of Michael Mattis and Judith Hochberg
pp. 55, 59: courtesy of the artist, Thomas Dane Gallery,
London and Simon Preston Gallery, New York
pp. 56, 57: copyright Andy Keate
p. 59: courtesy of Center for American History,
University of Texas at Austin
p. 67: courtesy of the Freud Museum, London
pp. 74, 75: copyright Nadia Bettega
p. 77: courtesy of Theatre Royal Stratford
East Archive Collection
p. 85: copyright Benedict Johnson

MAYOR OF LONDON

LOTTERY FUNDED

Transport for London

ONE
THING
LEADS
TO
ANOTHER
EVERYTHING
IS
CONNECTED

**black dog
publishing**

london uk

Contents

Foreword

This book is the culmination of an Art on the Underground project for London Underground's Jubilee line: *One Thing Leads to Another—Everything is Connected*. It brings together the commissioned artworks and associated events produced and presented along the line in 2010 and 2011, with additional texts that add to and reflect on them. This is the second in an on-going series of line-based projects, the first of which, *Thin Cities*, on the Piccadilly line, established an important new strand for the programme.

The aim behind these series of commissions is to invite artists and their audiences to explore each line on the Underground network over a number of years. Underpinned by a key priority for Art on the Underground to enhance the experience of travelling on the Tube by bringing world-class artworks to its stations and trains, the series enables the continuing development of the programme into all parts of the vast network.

Art on the Underground combines opportunities for artists to make new work with the prospect of reflecting on and responding to the environment of the Tube. The artworks might directly or indirectly address anything from the long history of the network, the physical nature of its stations and the operation of the service, to the nature of travel itself. Time taken to travel from place to place is at the heart of any journey. The value of that time and the quality of the experience of being on the Tube is constantly addressed and measured as part of its service. Taking the value of time as a starting point for the Jubilee line series, the Art on the Underground programme curators invited a range of artists to propose artworks for presentation along the line.

This commissioning process led to a diverse range of responses. In some cases, the concept of time is taken quite literally through the production of moving-image based works that take time to experience. More than one project involved direct engagement with customers and staff, who gave up some of their time in the process of developing the work. In other cases, time in the sense of history was important: that of the line itself (which opened in 1979, with the extension to Stratford opening 20 years later in 1999) and of specific local communities, where a historical perspective was explored as part of the work. In addition to the commissioned artworks, a number of talks and events were scheduled throughout the project with experts from a range of related fields, allowing for further consideration of time and for conversations to be generated between artists, commentators and audiences.

The response to the Jubilee line set of commissions has resulted in the production of an intriguing collection of new works. Dialogues that opened up as these works were made and shown have continued to grow as part of this publication. It also provides an appropriate opportunity to acknowledge the hard work and commitment of the people who enabled the many facets of this project to come to fruition.

The Art on the Underground team deserve warm thanks and congratulations for the hard work and time they have put into this project and for what they have achieved through it. The additional support and work of TfL staff based in stations, trains and many other areas of the business is crucial for the successful delivery of our projects; many thanks to them for their continuing enthusiasm and help. A number of people based in other organisations have also made important contributions to the commissions and the public programme events, for which we are very grateful. Huge thanks go to Arts Council England for providing an important grant ensuring that the breadth and depth of the project could be delivered as planned. The Art on the Underground programme would be nothing without the artists with whom we work, so we extend an extremely important thank you to them all for the ideas and commitment they brought to the project. Their trust in the programme team to work with them to deliver their projects in such a challenging context is always greatly appreciated. Finally, it will become apparent to the reader of this book that many hundreds of people are involved in the Art on the Underground programme and contribute to its success. Their continuing support and belief is at the core of the programme and is what drives the team to continue to ensure that its audience encounters and experiences works of the highest calibre and quality.

Tamsin Dillon, Head of Art on the Underground

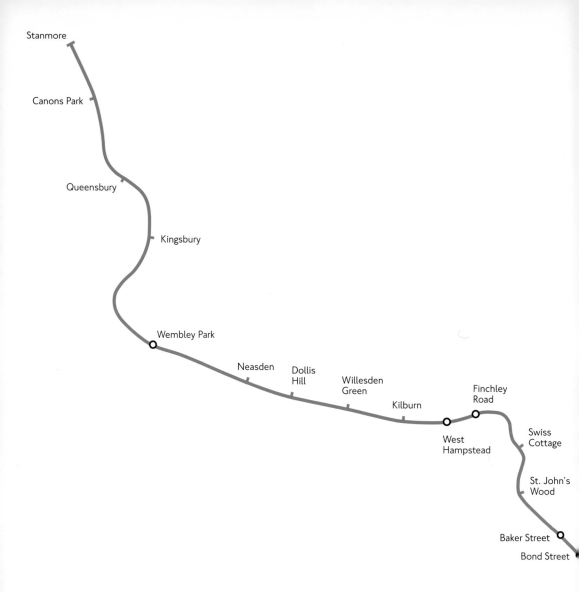

Stanmore

Canons Park

Queensbury

Kingsbury

Wembley Park

Neasden

Dollis Hill

Willesden Green

Kilburn

Finchley Road

West Hampstead

Swiss Cottage

St. John's Wood

Baker Street

Bond Street

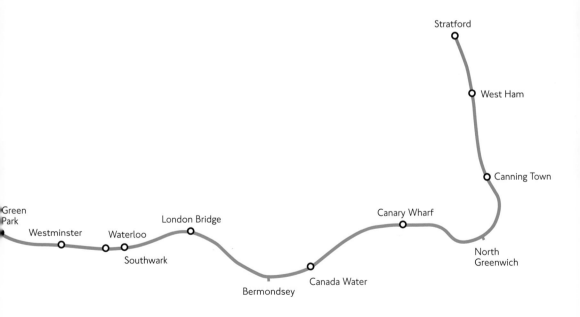

Green Park

Westminster

Waterloo

Southwark

London Bridge

Bermondsey

Canada Water

Canary Wharf

North Greenwich

Canning Town

West Ham

Stratford

Geographic map of the Jubilee line.

Introduction

In the time it takes to read this, seven trains will have carried over 5,500 passengers on a section of the Jubilee line.[1] Just 30 years ago, such speed and volume of traffic on the line was unimaginable. Equally inconceivable was the transformation of the post-industrial Docklands area in East London into the financial district of Canary Wharf, as well as the development of Stratford for the creation of London's Olympic Park.

Rapid advances in information and mobile technologies are playing a key role in the accelerated pace of life today. As cultural theorist Paul Virilio has said, "the invasion of the instant replaces the invasion of territory".[2] It is interesting to consider the impact of these changes in contemporary life on our relationship with time and place.

To mark the 30th anniversary of the Jubilee line in 2009, Art on the Underground conceived, developed and presented a series of commissions examining the theme "the value of time"—linked to London Underground's core ethic of Valuing Time. Each artist was invited to explore concepts of duration, economics and social exchange, as well as the Jubilee line's integral role in the city's infrastructure and history from 1979 to 2009. This book documents, celebrates and explores that ambitious series of projects, as well as presenting a newly commissioned essay on the history of the Jubilee line by David Rooney, Curator of Transport at the Science Museum, London and a fictional approach to the concept of time by writer Matthew Stadler.

The title of the series, *One Thing Leads to Another—Everything is Connected*, is borrowed from a limited-edition print made by Richard Long for this project. The print, developed from the artist's solitary walk in the Cairngorm Mountains in Scotland, combines a photograph of a spectacular mountain scene with an overlaid text. Given away free to thousands of Tube users, it provided a stark contrast to the urban context of the Jubilee line. The artist's walk, his print and the distribution of it on the Underground set up an interplay between travel, time and place that became a fitting starting point for the Jubilee line series. Each artist took the commission as an opportunity to consider his or her own interpretation of time in relation to the complexities of the Underground. The responses took a variety of forms, resulting in intriguing new works of art, with open-ended questions at their core.

Daria Martin's work *Jubilee line customer daydream survey* was an inquiry around how people occupy their time on the Underground. The perception of time is malleable, shaped by expectations, perceptions and experiences. A minute's wait for the next Tube

can seem like an eternity—perhaps due to expectations of quick service—or it can apparently go by in a second. What is it about travelling on the Underground that can alter the perception of time and what strategies do people use to manage this? Martin's project set out to explore these questions amongst the Underground's vast community of passengers.

This question of the passage of time, how it is understood and experienced by individuals was implicit within each artist's commission. Photographer Nadia Bettega engaged a group of young people from Brent Youth Inclusion Programme to use time as a positive constraint. Across five days, they were given time to work with Bettega to invent and inhabit fictional personas in quick response to a series of new locations and to record these moments in the photographic portraits that were created.

The artists and writers from the Goldsmiths Art Writing MFA course took an approach to time that was different again—offering *Timepieces*, a booklet given away to customers and featuring new writing and drawing by the group in response to London Bridge station and the Jubilee line, which importantly offered passengers a way to use their time whilst travelling on the Underground.

The installation of *Oil Stick Work (Angelo Martinez / Richfield, Kansas)* 2008, invited the commuter to consider the investment of time in labour. John Gerrard's digital moving-image work lasts for 30 years and ran for 24 hours a day in the ticket hall of Canary Wharf station over the course of one year. The work's virtual protagonist, Angelo Martinez, is locked into a painstaking and laborious task against the backdrop of a post-industrial landscape of Kansas, USA. Located in the world of "high-frequency trading" in the heart of the City's international financial district, *Oil Stick Work* invited questions about different global economic scales and what value we place on time.[3]

In transport economics, for instance, time is valued according to how much a passenger would be willing to pay in order to reduce the time spent traveling. The value of time varies depending on the purpose of the journey and is divided into 'working time' and 'time outside work'. It is pertinent that questions around how time is valued should be considered in relation to the Jubilee line and its Extension, conceived to serve the transport needs of East London's new economic workforce, and to support significant events in London's cultural and political growth at the start of the new Millennium such as the new Tate Modern and the creation of the Greater London Authority (GLA) in 2000, followed by the opening of City Hall in 2002.

Digital imagery pervades new areas of the urban experience; from advertising screens to hand-held devices, an assault of

instant messages has become the norm. As theorist Benjamin H Bratton has observed, since the advent of audiovisual media, in modern society attention is fixed on a centre 'not of buildings, but of *screens*'.Ð Artworks by their nature run counter to this, requiring time and enquiry from the viewer. Their role within the public realm is, perhaps, to offer an alternative, a space to pause and reflect. Locating art outside the gallery triggers a new set of considerations, requiring an awareness of the environment, as well as sensitivity to those who use it. Translate these concerns to a transport system, London Underground, and an even greater challenge exists: how best to gain the attention of a mass, transient audience amongst a host of other distractions.

For Matt Stokes this issue was central to his approach to Stratford. Conscious of the variety of ways in which people would encounter his project in this busy station, he conceived of a multi-channel film work on the mezzanine level, encompassing a series of fleeting acts by local performers that played on a loop. *The Stratford Gaff: A Serio-Comick-Bombastick-Operatick Interlude* draws upon the area's Victorian history when there was a profusion of popular entertainment, now under-documented and for the most part forgotten, aimed at the growing labour-force. The Stratford Gaff could be understood as an attempt to redress this disparity through a contemporary document.

Just as Stokes' work is a portrait of Stratford, as seen through a historical lens, *Linear* by Dryden Goodwin is a 'speculative' portrait of the Jubilee line at a specific moment, humanised by its staff. Goodwin's epic undertaking played with the notion of time in a variety of ways. Taking an idea from the Jubilee line workers themselves, he marked the 30th anniversary by creating portraits of the staff based on the line during that year, through a highly compelling series of drawings and films. This meant a huge investment in time, both for Goodwin and the staff, the recording of events over time, and a consideration of how time would be spent by audiences in experiencing the works as both still and moving image. For Goodwin, the moving image was employed as a way to enable the viewer to 'travel back in time' to his encounter with his sitters. The artwork itself was inserted back into the Underground network by appropriating its advertising screens; Goodwin employed the language of digital adverts, condensing time to reveal the evolution of the drawings.

City Hall and the Royal Observatory Greenwich (home to GMT) were fitting locations for a series of public discussions held in collaboration with Public Programmes Dept, Royal Museums Greenwich and David Rooney, Curator of Transport, Science

Museum. Experts from fields including Horology, Navigation, Design History and Transport Planning raised further issues relating to themes of time, travel and the Capital, including imperfections in time-keeping and the entwined relationship between time and navigation, modernity and speed.

One Thing Leads to Another—Everything is Connected took three years from conception to completion. Over this period, a constellation of lasting relationships and unexpected histories have evolved, enriching the artworks as a result of the time invested by each artist, participant and partner. This was enhanced by the public's encounters with and response to the artworks on London Underground, from those who sought them out (at stations or online) to those who happened upon them as an unexpected part of their journey. As a means of recording the series, this publication uses similar strategies to those employed by Harry Beck for his iconic Tube map—a distilled portrait of the city that collapses time and geography to assist navigation through the Underground. Since it would be impossible to document every detail of the project, these pages aim only to serve as an entry point from which to begin this particular journey along the Jubilee line.

Louise Coysh, Curator, Art on the Underground

1 In 15 minutes during morning peak, over 5,500 people will have travelled on the section of the Jubilee line from Canada Water to Canary Wharf: over 800 passengers for each of the seven trains scheduled at that time. Figures derived from RODS (Rolling Origin and Destination Survey) 2011 and based on timetable at time of writing.

2 Virilio, Paul, *Speed and Politics: An Essay on Dromology*, Los Angeles: Semiotext(e), 2006.

3 The term "high-frequency trading" is the name for a computer-driven investment trading strategy that emphasises high transaction volume, extremely short-duration positions and rapid rule-based automated buying and selling, high-frequency trading is performed by computer algorithms operated by investment companies that react to pre-specified market conditions to generate short-term profits. Read more: www.businessdictionary.com/definition/high-frequency-trading.html.

4 Bratton, Benjamin H, "Logistics of Habitable Circulation", in *Speed and Politics: An Essay on Dromology*, ibid, p.10.

Place and Time on the Jubilee line

The Jubilee line is defined by contrasts. It links the once-thriving London docks in the east to the consumer heartlands of the West End. It connects the erstwhile seat of London's local government in Waterloo, south of the river, to the Houses of Parliament at Westminster to the north, two political pugilists in stone and terracotta facing off as if for a fight. And it enables inner-city and suburbia to come together.

It is, of course, a microcosm of London itself: a perpetual layering of the new onto the old, a complex network of people, places, ideas, ambitions, pasts and futures. It has tracked London's shifting centre of gravity, which is rapidly moving east, and it helped a nation mark a millennial *fin de siècle*. It is a history lesson in iron and concrete. In infrastructure, nothing is ever really new. The Jubilee line simply layers new journeys onto old ones.

Time

"Dollis Hill comes nearer to being a paradise than any other home I ever occupied", Mark Twain, 1900.

The first phase of the Jubilee line opened in 1979, with the completion of a new Tube tunnel from Baker Street to a temporary terminus at Charing Cross. The section north of Baker Street to the northern district of Stanmore was taken over from the Bakerloo line, which had been plying the route since the 1930s. But even this was

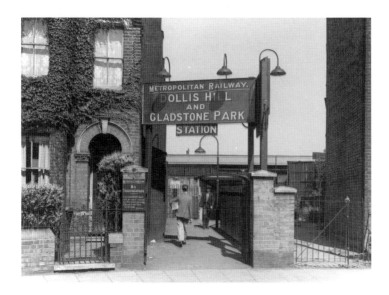

not the origin of what we now call London's newest underground line. Upon its opening in 1979, the Jubilee line ran over tracks first served by steam trains on the Metropolitan Railway a century earlier.

The Jubilee line is a perfect example of recycling. The context changes, journey patterns shift, and the network evolves and adapts. *Plus ça change, plus c'est la même chose*. And there are stories hidden in those northern suburbs.

Take a trip to Dollis Hill, atop the heights of north London. It is set around Gladstone Park and its recently demolished Dollis Hill House, described by Mark Twain as a "paradise". For Twain, there was "no suggestion of city here; it is country, pure and simple, and as still and reposeful as is the bottom of the sea". The park can still be considered *rus in urbe*, the perfect retreat from the pressures of modern city living with its computer-controlled split-second timing. It remains as still and reposeful as Twain described.

Yet climb the hill through Gladstone Park and you will reach a

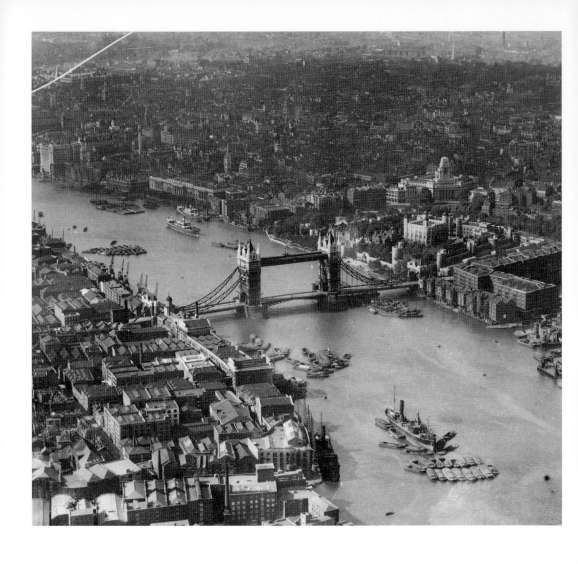

The heart of London, c. 1928.

modest brick-built housing development surrounded by light-industrial units. It is an unremarkable suburban scene now, but during the Second World War the apartment block and the industrial estate formed the Post Office Research Station, and within its buildings were constructed some of the most extraordinary machines of the twentieth century.

The Dollis Hill sheds housed the building of the codebreaking *Colossi*, the world's first programmable electronic computers, used to crack enemy codes at Bletchley Park during the war and inspiration for the universal computers that keep us constantly on the go today. Also created at Dollis Hill in the 1940s were the super-accurate quartz clocks that first convicted the Earth of bad timekeeping, and convinced the astronomers at Greenwich to abandon pendulum clocks forever. Your quartz watch is based on Dollis Hill technology, and your kitchen clock.

Hidden stories of places and times are revealed on Jubilee line journeys. The way we move, the way we connect with others, the way the world has shrunk over the past half-century has been shaped by the work done in a small group of modest buildings in suburban Dollis Hill, and this is only one story. The Metropolitan line trains now thunder past without stopping, saving their passengers valuable minutes. But sometimes the slow lines offer their own reward.

Place

"London takes a lot of understanding. It's a great place. Immense. The richest town in the world, the biggest port, the greatest manufacturing town, the Imperial city—the centre of civilisation, the heart of the world!" HG Wells, *Tono-Bungay*, 1909.

For the Edwardians, London was the centre of the world, and the docks were the beating heart of the capital, pumping goods, capital and influence around its streets. What a difference a century makes. By the 1960s the docks were rapidly losing trade in the wake of changing labour and industrial patterns and the shifting geographies of production and consumption. When the Jubilee line first opened in 1979, the old docklands had become a wasteland, a brutal and haunting reminder of a past world. New container ports downstream had begun to render London's maritime heart invisible, and its legacy in the decayed East End was an unwelcome reminder.

But 20 years after the Jubilee trains first began to run, the docklands had been transformed. Part of the vast West India Export Dock on the Isle of Dogs had been drained, lined out and turned into the station box of Canary Wharf station on the line's new extension. The docks were fast becoming the heart of a new London, one built of glass, steel and ambition. A market-led property development boom, set running with the creation of the London Docklands Development Corporation (LDDC) in 1981, had changed the face of the capital.

But, as Wells told us in 1909, "London takes a lot of understanding". Whilst the Jubilee line enables us to make new journeys and reach new places, it is not simply an artery, or a means to an end. We see the

underground as a device, a machine for transporting us, a *non*-place. While this is quite natural, it is a sickness. We submit to it far too easily, but we can fight it. Arrive early. Take more time. Look around! The underground is a place, and art helps us to understand it.

Take *Linear*, Dryden Goodwin's series of 60 pencil portraits of underground workers, which was accompanied by short films recording the drawings being made. Here, Goodwin and the participants helped reveal to us an underground system that is in reality a series of workplaces: locations where lives are spent, dreams conjured, realities enacted. The old docks were once thronged with people at work. Today, the context has changed, but lives are still lived there. Far from being a non-place, the Jubilee line is the very fabric of daily life. It is part of us, and we of it.

And its fabric reaches much further than the platforms and tunnels. Sited in the heart of the old West India dock, John Gerrard's *Oil Stick Work*, which unfolded at Canary Wharf station between May 2010 and May 2011, offered an absorbing vision of real-time connectedness. On a huge screen, we watched a virtual Angelo Martinez paint a digitally created industrial grain silo in Kansas. It didn't matter that the scene was virtual. Martinez was painting in real time and, as the London crowd hurried by, Gerrard's work turned Canary Wharf station *and* the Kansas silo into real places. We were once more in the heart of the world.

People

"I think it is better for me... to look at the trees, and the sun, moon, and stars, than at tunnels and docks; they make me too humanity proud", Fanny Kemble, after a visit to the Thames Tunnel, 1827.

In 1827, Marc Brunel and his son Isambard held a candle-lit banquet in their part-finished Thames Tunnel between Rotherhithe and Wapping. Dignitaries and celebrities had been invited to visit the tunnel, and the publicity was good for business. Inundations had caused injury and deaths, and the project was teetering on the edge of bankruptcy. But the Brunels were confident of their scheme and wanted to show prospective backers that Londoners could cross the Thames underground. For the technophile actress and author Fanny Kemble, the tunnel resembled 'the beautiful road to Hades'—a sublime vision of London's future.

The Thames Tunnel was originally designed as a carriage tunnel but opened in 1843 as a pedestrian promenade, after money to build carriage ramps at each end dried up. It was taken over by the East London railway in 1869, and now forms part of London Overground, which connects with the Jubilee line at nearby Canada Water. It is the oldest piece of underground infrastructure on the Tube network today, the first tunnel ever dug under the river, and once the most thrilling sight in the city.

70 years later, another group of men and women began tunnelling under the Thames. In the space of just 15 years from 1897, four further cross-river tunnels were built, linking communities in south London to their opposite numbers north of the river: the Blackwall

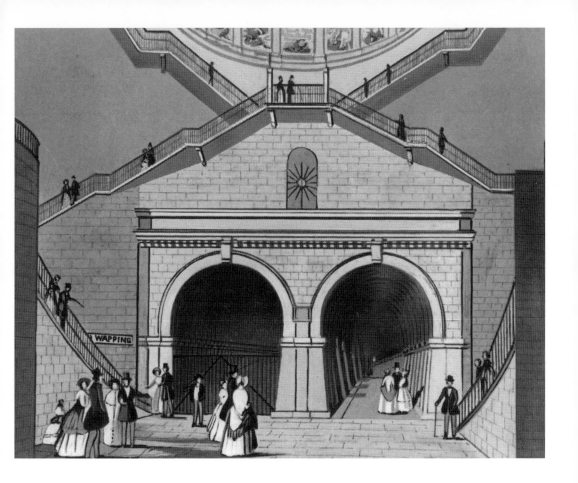

The Thames Tunnel, c. 1843.

and Rotherhithe road tunnels and the Greenwich and Woolwich foot tunnels. All were built by the London County Council (LCC) and all are still in vital daily use.

Today, it is no fun walking through the Rotherhithe Tunnel. It does have footpaths, but it is a noisy, choking, frightening experience. Instead, take the Jubilee line to Waterloo and stand on the river terrace of County Hall, LCC headquarters from 1922 and the proudest statement of municipal confidence imaginable. It is a genuinely provocative building, its chest puffed out to face Westminster over the river.

For many, County Hall is indelibly associated with its more recent history as the seat of the Greater London Council, abolished by Margaret Thatcher in 1986. Thatcher's London Docklands Development Corporation and the huge changes in the docklands since the 1980s symbolise new political approaches to the problems of London. Canary Wharf helped conjure in to being the Jubilee line extension, with its four new river crossings. But whichever political

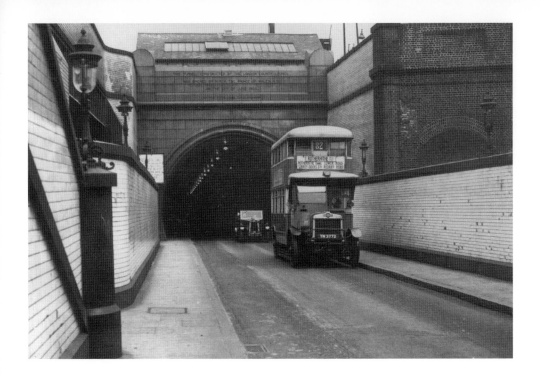

hue takes the chair, the results reshape the fabric of London.

Infrastructure is a remarkable testament to the ambitions of imaginative men and women. It is hubris in built form. It involves the sinking of fortunes and reputations into the most precarious of ventures in the hope of making a lasting mark and defeating topographical barriers like the Thames, which divides London in two. And the results live with us for a long time. The ambitious people of London's past are memorialised in brick, stone, steel and concrete—and a few people in a short time can change the capital forever.

Future

The Jubilee line extension was completed from Stratford to central London in November 1999, just in time for the celebrations at the Millennium Dome, on the Greenwich peninsula. All eyes were on the clock that year. Time was running out for infrastructure projects like the extension, because time was running out for the second millennium.

And time was at the heart of the Dome, its 12 support masts deliberately echoing the 12 hours or the 12 months, its western boundary grazed by the world's Prime Meridian, from which all time and space are measured. The Dome represented a moment in time, but it was also grounded in the past. The soil beneath

Opposite
Rotherhithe Tunnel, 1936.

Below
County Hall and the River
Thames, 1923.

its foundations was once the site of the largest gasworks in Europe, and it was an enormous job to clean it up for the new millennium. That's the past for you: dirty, lingering. But we're built on it.

What a remarkable set of contrasts we can experience on this silver-grey way-finder through the capital. The Jubilee line is a time machine. It transports us into a grimy past and an uncertain future, from city to suburbs, new London layered on old. We have seen the way in which time and place are threads that connect human stories about London journeys. The Jubilee line has truly been shaped by the fabric of London, and by its people, as it simultaneously shapes them. And it will continue to be so.

David Rooney, Curator of Transport, Science Museum

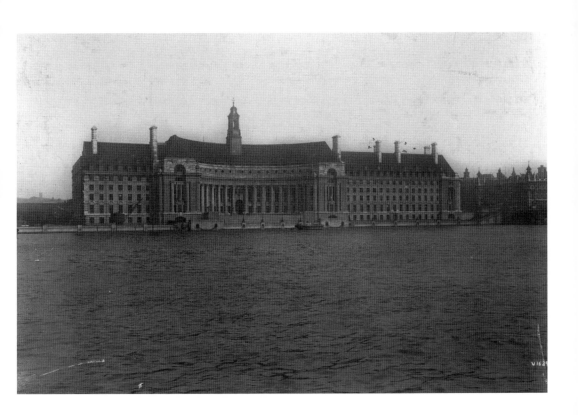

1979–2009
Time, transport and the Jubilee line
David Rooney, 2010

1979

Jubilee line opens
May
The Jubilee line opens for business, connecting Stanmore and Charing Cross. It takes over one branch of the Bakerloo line with a new connection from Baker Street down to Charing Cross.

1980

London Transport Museum opens
March
The London Transport Museum throws open its doors in a converted 1870s flower market building at Covent Garden. Appropriately, the iron and glass structure resembles a railway station.

First 24-hour TV news channel
June
CNN, the first 24-hour TV news channel, begins to broadcast its non-stop reports and stories. Traditional time boundaries have long been breaking down as we move towards always-on, round-the-clock living.

1981

Isle of Dogs become developers dream
July
The London Docklands Development Corporation is formed, giving free rein to market-led property development in the historic Isle of Dogs. This has huge consequences for transport needs in the area.

Tube counts down to next train
July
The "next train" countdown board is put on trial at St James's Park station, beside London Underground headquarters. Passengers can now see precisely how long they'll have to wait to get on board.

1982

Flight of the historic heron
June
Captain Harry Gee lands a de Havilland Dash 7 aircraft on Heron Quay testing the ground for a new London airport in the docklands. The Canadian-developed light aircraft proves ideal for the task.

Docklands transport plans take off
August
Proposals are revealed for two major transport developments: a privately funded Docklands Light Railway, and an airport at the old Royal Docks. The year has seen crippling transport strikes in the capital.

1983

Timepiece becomes one to Swatch
March
Swatch, the first disposable fashion watch, goes on sale. The Swiss watch industry is revolutionised by this light-hearted, style-conscious brand, and the watches become highly collectable.

Navigaton error kills 269
September
The USSR shoots down a Korean aircraft that had strayed into their airspace following a navigation error, killing 269. America vows to make its GPS military satellite navigation system available to civilians.

Time the most accurate measure in the universe
October
For the first time in history, length is no longer defined by how long something is. It is the distance travelled by light in a particular time. Time is now the most precisely measured quantity in the universe.

1984

World moves close to catasthropic destruction
January
The 'Doomsday Clock' run by top atomic scientists is moved to three minutes to midnight, closer to the 'midnight' of catastrophic destruction than at any time since the advent of the hydrogen bomb in 1953.

1987

Direct line to the docks
July
HM The Queen opens the Docklands Light Railway, connecting Stratford and the Isle of Dogs to the central London transport system. The driverless trains glide along on a diverse mix of old and new tracks.

Mobile phone revolution begins
September
The Global System for Mobile Communications (GSM) agreement is signed, a mobile phone system now responsible for connecting more than three billion people in over 200 countries.

City Airport takes flight
October
Airline passengers check in to the newly opened London City Airport, set on a quay by the former Royal Albert Dock. The airport is later officially opened by HM The Queen.

King's cross fire kills 31
November
A fire at King's Cross Underground station kills 31 people. New safety legislation introduces stringent requirements for subsequent underground construction, including the Jubilee line Extension.

1985

**Canary wharf
goes cheep**
October
A proposal is announced, led by American developer G Ware Travelstead, for a massive property development at Canary Wharf, once a fruit warehouse on the Isle of Dogs.

1989

Jubilee Line is ten years old
May
It is ten years since the Jubilee line first opened, connecting Stanmore in the north of the capital to a temporary terminus at Charing Cross, the heart of London. Plans are afoot for a major extension.

1986

**Slow Food on
the Spanish Steps**
March
The Slow Food movement takes root in Italy, in response to McDonald's opening a branch of their fast food restaurant chain near Rome's historic Spanish Steps.

**John Cleese
goes clockwise**
October
EMI releases *Clockwise*, a film starring John Cleese as headmaster Brian Stimpson, portraying one man's disastrous quest for punctuality. Stimpson runs his school like clockwork, but one day it all goes wrong….

1988

A Brief History of Time
April
Physicist Stephen Hawking releases *A Brief History of Time*, a book that becomes a surprise best-seller. Its complex contents are made straightforward, with only one equation in the whole volume.

**Fireworks at
the Royal Docks**
October
French musician Jean Michel Jarre performs two blockbuster live concerts at the Royal Victoria Dock to an audience of 150,000, lighting up the area with spectacular lasers, fireworks and sound.

1990

Radio-controlled wristwatch released
May
The Junghans "Mega 1", the world's first radio-controlled wristwatch, is released. It receives the same corrective radio time signals as railway clocks across the railway network.

BBC gets pips
February
The Royal Observatory moves from Herstmonceux Castle in Sussex to Cambridge. Timekeeping duties for the 'six pips' time signal are handed over to the BBC for the first time since 1924.

Canary Wharf gets iconic landmark
November
A steel pyramid is placed on top of the tower at Canary Wharf, marking completion of this major new London landmark. The aircraft-warning light at the apex, visible for miles, flashes on a 1.5-seconds beat.

1991

Olympia & York head for the tower
August
Olympia & York, Canary Wharf's first tenants, move into the 29th and 30th floors of the iconic tower, signalling a rush for occupancy. A monumental DLR station opens at the heart of the complex.

1992

Angel gets stairway to earth
August
The longest escalators in Britain are installed at Angel Underground station, replacing lifts as part of a major redevelopment that greatly speeds up passenger flow at this deep-level Northern line station.

1993

Jubilee line Extension gets seal of approval
October
John MacGregor, the Secretary of State for Transport, gives his written authority for construction of the Jubilee line Extension to begin, after years of complex planning.

Major drives first pile
December
At a ceremony to mark the beginning of construction of the Jubilee line Extension, the first pile is driven at Canary Wharf by Prime Minister John Major. The project has begun.

1994

London Underground takes 'the drain'
April
London Underground takes responsibility for the Waterloo and City, London's shortest tube line, from British Rail. With the recent arrival of the Docklands Light Railway, Bank station becomes a major hub.

Tunnel collapse halts extension
October
A Heathrow Express tunnel being dug using the same technology as the Jubilee line collapses, opening a huge hole between two runways. Parts of the Jubilee line Extension project grind to a halt while investigations take place.

1995

Boring machine breaks record
October
While constructing the Jubilee line tunnels near North Greenwich, a tunnel boring machine breaks records by cutting 254 metres in one week—a blistering speed of 0.001 mph.

Ten-billion-year time machine revealed
December
The remarkable Hubble Deep Field photograph offers the deepest and most detailed view into the farthest reaches of the universe ever seen. This time machine shows objects as they were over ten billion years ago.

1996

Greenwich set for millennium
February
North Greenwich is selected as the site for Britain's official millennium celebrations, setting an immoveable deadline on completion of the Jubilee line Extension that will serve the area.

Startford and Westminster joined
August
All the running tunnels on the Jubilee line extension are completed. With four subterranean river crossings, the line will be a hugely important addition to London's transport network.

1997

Final days for timekeeping mecca
August
Permission is given for the buildings of the old
Post Office Research Station at Dollis Hill, which
developed pioneering quartz clocks for the Royal
Observatory, to be converted into housing.

1998

Ebb and flow on the Westferry Road
A row of clocks by noted sculptor Richard
Wentworth is completed on a Docklands wall.
"It is international time zones which dictate
the ebb and flow of business life at Canary
Wharf", says Wentworth.

Clock ticks for millennium celebrations
June
The Millennium Dome building is ceremonially
topped-out, reminding all working on the
Jubilee line Extension nearby that the clock
is rapidly counting down to midnight on 31
December 1999.

Green light for Jubilee trains
July
The first train runs under signalled control on
the Jubilee line Extension. This is a major
landmark for the project and refocuses attention
on the highly complex station building sites.

Swatch switches world time
October
Swiss watchmakers Swatch introduce "Swatch
Internet Time", a decimal timescale in which the
day is divided into 1,000 'beats' and there are no
time zones. New watches share the beat.

Time is called on Royal Observatory
October
The Royal Greenwich Observatory is officially
closed down after 323 years of scientific
research measuring space and time. Since the
1960s, Britain's official time has been measured
by physicists, not astronomers.

1999

Clocks mark time for Canary Wharf
Designer Konstantin Grcic installs his playful
artwork, *Six Public Clocks*, by the iconic towers
in Canary Wharf. The double-sided clocks are
based on Swiss railway timekeepers, but each
dial has only one numeral.

20 years of Jubilee journeys
May
The first phase of the Jubilee line Extension,
from Stratford to North Greenwich, is
opened to passenger service by Deputy
Prime Minister John Prescott, 20 years
after the original line opened.

On the buses for the Dome
July
The Transport Minister, Helen Liddell, opens
the Norman Foster-designed North Greenwich
bus station, capable of handling a bus departure
from the Millennium Dome every 50 seconds.

Greewich meets its Waterloo
October
The second phase of the Jubilee line Extension,
from North Greenwich to Waterloo, is opened
to passenger service. The clock is ticking for the
final completion of the landmark project.

Extension finally joins east to west
November
The full route of the extended Jubilee line,
from Stratford to Stanmore, is opened to
passenger service, in time for the national
celebrations on New Year's Eve focused on
the Millennium Dome.

London lighthouse gets
millennium of music
December
"Longplayer", a piece of music by Jem
Finer that will play for 1,000 years without
repeating, begins to sound in an abandoned
lighthouse near Canning Town, opposite the
Millennium Dome.

10,000-year clock ticks
December
The Clock of the Long Now, the prototype
of a mechanical clock that will operate for
10,000 years, begins to tick in San Francisco.
It is transferred to London's Science Museum
months later.

2000

Underground art finds platform
London Underground's Platform For Art
programme is launched, revitalising a
long and proud tradition of art and design
commissions for the underground network
dating back to 1908.

Tree-mendous success
March
St James's Park is the scene of a tree-
planting ceremony, presided over by the
Duke of Gloucester, to commemorate the
completion of the Jubilee line Extension.

Satellites navigate out of this world
May
The GPS satellite navigation signals provided
by the US navy are made available to civilian
users with full military accuracy for the
first time, transforming civil transport from
airliners to black cabs.

2002

City Hall opens for business
July
HM The Queen opens the Greater London
Authority's new headquarters building, City
Hall, by London Bridge. The energy-efficient
structure is designed by Canary Wharf
station architect Norman Foster.

2004

Silver for Jubilee
May
The Jubilee line is 25 years old, celebrating its very own Silver Jubilee. The extension to Stratford clocks up its first half-decade as the docklands area and the East End continue to grow.

2005

Hands-free landing makes pilots invincible
June
The world's first automatic landing of a fighter aircraft onto the deck of a ship takes place using satellite navigation. The pilot takes no control in the landmark landing on *HMS Invincible*.

2006

Time comes first
June
Oxford University Press reveal that "time" is the most common noun in the English language. "Year" is said to be the third most popular, with "day" coming fifth and "life" at number nine.

Public asked to speak precisely
October
Phone lines open for the British public to audition to be the fourth official voice of the speaking clock, first introduced in 1936. 18,400 entries are recorded, and Sara Mendes da Costa is announced the winner.

2007

Time out for Rugby radio
March
Britain's official time signal, a radio broadcast known as MSF, is switched from its original site at Rugby, Warwickshire (where time had been broadcast since 1927) to a remote mast at Anthorn, Cumbria.

Pips get the pip
September
AT&T withdraws its speaking-clock service across California, the penultimate US state to keep the system. Nevada's service, the last in America, will be allowed to continue until its equipment breaks down.

Clock restorers escape doing time
November
Cultural guerrilla group "Untergunther" is cleared of lawbreaking by a French court, following its one-year secret project to restore the iconic public clock in Paris' famous Panthéon building.

2009

Timekeepers finally clock nano-time
Super-accurate atomic clocks at America's National Institute of Standards and Technology are built that routinely keep time to within a few thousand-million-millionths of a second. It's a nano-revolution.

Big ben tolls 150th
May
150 years have passed since Westminster's Great Clock, known as Big Ben, was set running. Over the following century-and-a-half, Big Ben has established a powerful and much-loved tempo for London.

Jubilee turns 30
May
30 years have passed since the Jubilee line first opened for business on 1 May 1979. Much has happened in London during this time, with the East End and the docklands changing out of all recognition.

New art for the Underground
November
London Underground's Platform for Art launched in 2000, is renamed Art on the Underground. Showcasing world-class art for a world-class Tube, the programme enriches the journeys of millions every day.

Sculptor remembered for Queen of Time
December
A blue plaque is unveiled on the former St John's Wood home of sculptor Gilbert Bayes, who created the *Queen of Time* sculpture supporting the iconic clock on the Selfridges store by Bond Street station.

Samson Occom on the Jubilee line

I board at Westminster, in a nobleman's house. Mr Hotham sent me. There was a form and a procedure, but they were set aside because the lady doubted I could write. My accent charmed her. I am North American. My English is not proper, I'm told. Ditto the lady, who is Welsh. Mr Whitaker takes his lodgings elsewhere, thank the Lord. Some here said I would not speak at all, being "savage", but now all they ever ask me to do is speak.

On Wednesday I speak at Charing Cross. My subject is the woodland animals of Connecticut. Gentlemen gather for luncheon, followed by me. I can hardly tell what time it is, but invariably I am "on time". Church bells ring everywhere and London has flocks of birds, many of them strange to me, but regular enough in their habits. They enter and leave with the phases of the day. I came by ship, over boisterous seas.

The lady's friendship exceeds our agreement. Our faces ache from smiling. She throws a rug over my back and calls me "caribou", then hits me with a stick. We laugh and laugh. Her speech is gibberish, like grackles. The lady is boisterous, but her assaults are friendly, if I am correct. I will describe events as accurately as I can, to which I obliged myself when I took this commission, to raise funds for the Indian Charity School and to write about this place and its customs.

I shall speak of foods. Their preparation is crude, for the most part boiling until everything is soft. Meat is boiled for a long time so that it is soft, which is pleasant if one has no teeth. My lady has no real teeth to speak of and has all her meats boiled. I gather purslane and wunipaqash from the bog at St James to give it flavour. Potatoes are common, which can be fine roasted, but mostly they are boiled with meat and the two cannot be distinguished after. Lepers are buried here.

Mr Whitefield gave us Mary Joyner and her son Randal, whom my lady enjoys immensely. The boy has become indispensable to us. He is fine and wiry like a stick. Randal was born a heathen and stayed so. Mr Wheelock changed me when I was not yet a man. Mr Whitaker is a plague. He is Wheelock, unbound. Randal taught me a trick—when a worry shadows my thoughts, I push it down out of me, through my feet, into the ground. Then I am rid of it. People under the ground can have it.

The news from Boston is months old, but letters arrive every day. Pauline has birthed a healthy baby boy! The world is so small. It takes longer to traverse Wales than to get to New Brunswick, but no one ever goes to Wales. Everything is in London. I am in London. The English are Christian, for the most part, but also worship rocks and trees. I smell oak and beech when the wind blows from Hampstead Heath.

The clouds above the Heath are marine. At Charing Cross a lady asks if I believe in God! The Mohegans have always helped the English, tant pis. Naquatiyi asokikámá. Mahomet came here before me, and Oweneco before him. Mahomet caught smallpox at Mr Midhurst's in Aldermanbury and was the first Mohegan to die here. He is interred in St Mary Over's burial place. A rock sits there now, a gift from the Scots tribe, enemies of the English. Mr Whitaker gave me the inoculation against the pox.

Mr Whitefield dictates the day's itinerary. Stratford and Southwark in the morning, to speak to Episcopal congregations. Dinner near London Bridge with Mr Hotham. There is a kind of fish that is famous and which I am told I must eat. I will thank Whitefield for Mrs Joyner and Randal, who accompany us on our rounds. After dinner, bowling with Mr Legge at White Hall. All will be heavy with drink. Here is where the money is raised. It helps that I am sober and a man of God.

Whitefield has promised to show me the law and what is customary here. In Hyde Park Randal reveals an astonishment—gay gentlemen, in partial dress, ladies too, a-maying in the woods with disreputable fiddlers, etc., gathering bowers and sinning. Teams of men, 50 each, in red and white caps wrestle a silver ball across the length of a muddy field, like our "bump hips", but without the sticks. Randal tells me I will write my report on a mechanical contraption he has heard of, that sets type in sequence, and leave this place through a hole in the ground.

Mary Joyner tells me how Randal gained the power of divination. Two years past, when he was 12, his father put him in Wentwood Forest with only a crude hide for shelter. Nothing of civilised life had he, no clothing or tools or prepared foods. At dawn his father startled him awake, and with ipecac made him vomit then gave him a tiny piece of meat, the size of a finger. Every morning he did this. On the twelfth day Randal began to rise from the ground and soar through the air, and then he plunged underground, through rock, into the underworld where he was shown future things, and to this day Randal has the power of divination.

The city excites me beyond reason and shadows my mind with worry. Outwardly I am serene, but the crowds rake my nerves. When my lady drinks I cannot be near her and go outdoors where it is crowded with ruin and men shouting. The air tastes of coal. I suspect Mr Whitaker of playing me for a fool. The money I raise for Indians goes elsewhere. Mr Whitaker wants stock in a ship. I have been willing to become a Gazing Stock, yay even a Laughing Stock, in Strange Countries to promote Wheelock's cause.

Mohegan people came through a hole in a rock, west of New London. We came from the underworld. We were Pequot, but

the English divided us and we fought, children of a common mother. Everyone everywhere comes from underground. Pequot, Hopi, Cree, Welsh, Ojibway, Mixtec. In London the living return underground every day, pale and soft, to join the dead, God help them. I wait 113 years for the train to arrive.

The underground is endless, reaching everywhere. Pontiac's loss in Detroit waits on the platform at Canary Wharf. Mason Chamberlain has painted me at the behest of Mr Legge. He painted my boy, Randal, too, who dresses me, but Mr Legge thought Randal unimportant and had him torn from the canvas. Only the English have bothered to paint me as I am. The lady melts tallow and rubs it into my back and legs.

Dear Mr Wheelock: I fear your seminary is already aDorn'd up too much like the Popish Virgin Mary. Your college has too much Worldly Grandeur for the Poor Indians they'll never have much benefit of it. I verily thought once that your Institution was Intended Purely for the poor Indians with this thought I Cheerfully Ventur'd my Body & Soul, left my Country my poor young Family all my friends and Relations, to sail over the Boisterous Seas to England, to help forward your School. Regrets, Samson Occom.

We drink chocolate at the Cocoa Tree, which lifts my mood. The sun is bright. Randal has found the machine that prints letters swiftly in sequence and without an inkpot. Mr Henry Mill of Finchley built it, but the machine is cumbersome and cannot be operated without assistance. Mr Hotham has seen it, too, and knows the inventor. We hire a coach. The roads turn to mud immediately on leaving the city. I see foxes and circles of stones larger than men. Mr Mill lives modestly near a small creek.

Mr Whitefield takes me to a library near Baker Street to learn the law. We leave our overcoats with a man and present Mr Legge's card. Mr Whitefield conducts his business. Books are set on a desk in front of us. "It is called 'infidelity'", he explains, sounding the word out for me and turning the pages. "There is a law, but it only applies to men, proper." The law does not know me as a man, but as something else. I explain to Mr Whitefield that the lady and I do not lie together but he is indifferent.

My foot has become swollen with gout. The pain is debilitating and my lady keeps me in. Her laughter cannot cheer me. Mr Legge sends doctors who advise bed rest and that is what I commit myself to. Ministers, Lords, and other prospects visit and I am cheerful enough to persuade them, but the obligation and its labors are not restful. I tell Whitaker to send them all away. Randal puts pepper weed in Whitaker's toddy and that makes him sick so that he leaves us alone.

Randal takes me to the bear garden near Baker Street. Jubilee! I am something like a bear, in the eyes of the law. Chained to a pike for entertainment. Hounds are released in the pen and they bother the bear. A cynical keeper rubs grease on the bear's haunches and the dogs bite at it, which reminds me of my lady and delights me. Mr Legge condemns the bear garden, but it is no worse than his bowling alley. Men condemn whatever is not theirs, and if they think other men animals they condemn them too.

Despite seeming impossibilities at last I board the Jubilee line at Finchley Road. At this late hour I am obliged to do so, or be stuck here. I carry a small typewriter, which is broken. The only qualified man who agrees to fix it lives in Kilburn. He doesn't mind the time. Randal, by now grown and capable, secures tickets from a machine I cannot understand. It is our last trip together. I hope, someday, to return here, but such things are beyond my reckoning. Randal wraps his wiry arms around me, and the train departs the station, late.

The Mohegan, Samson Occom, was among the first indigenous North Americans to visit and write about London, as he saw it. In 1766, he travelled from Connecticut to Great Britain to raise money for an Indian Charity School for his people. He stayed there two years, mostly in London, and raised over 12,000 pounds. Portions of this text come from his letters and diary, though the events described are entirely fictional.

Matthew Stadler is a writer, editor and publisher based in Portland, Oregon

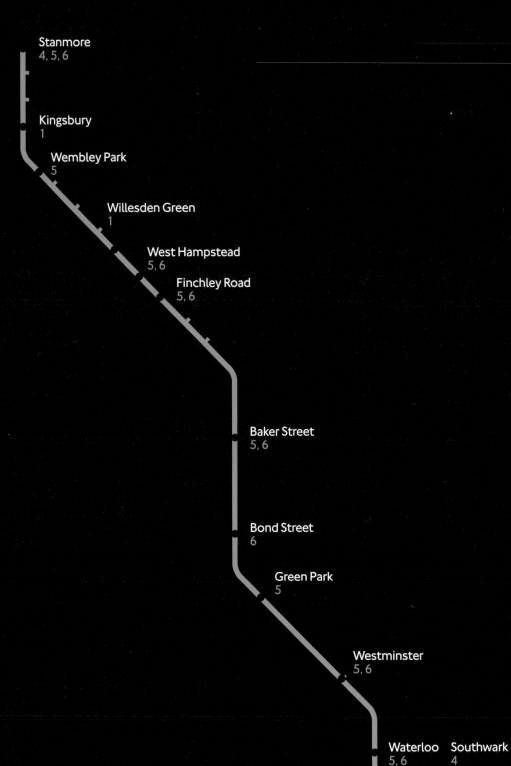

Stanmore
4, 5, 6

Kingsbury
1

Wembley Park
5

Willesden Green
1

West Hampstead
5, 6

Finchley Road
5, 6

Baker Street
5, 6

Bond Street
6

Green Park
5

Westminster
5, 6

Waterloo Southwark
5, 6 4

Projects

In the following pages, each project is represented by information and images, including an artist's biography and photographs of the artworks in-situ, as well as material selected in collaboration with the artists, such as interview transcripts, production images and reproductions of archival research. These are intended to enrich understanding of the artists' practices and to reveal the working processes, influences, references and methodologies that they have employed in their approach to the unique context of the Tube.

Artists

1 Nadia Bettega
 Threads
2 John Gerrard
 *Oil Stick Work (Angelo
 Martinez/Richfield Kansas)*
3 Goldsmiths MFA Art Writing
 Timepieces
4 Dryden Goodwin
 Linear
5 Richard Long
 *One thing leads to another—
 Everything is connected*
6 Daria Martin
 *Jubilee line customer
 daydream survey*
7 Matt Stokes
 *The Stratford Gaff—
 A Serio-Comick-Bombastick-
 Operatick Interlude*

Stratford
5, 6, 7

London Bridge
3, 4, 5, 6

Canary Wharf
2, 5, 6

ONE THING LEADS TO ANOTHER

A SEQUENCE OF THINGS
ALONG AN EIGHT DAY WALK
IN THE CAIRNGORM MOUNTAINS

MEMORY TO DESIRE
MAP TO WALKING
FULL MOON TO STONE CIRCLE
FROGS TO MIDGES
FOOTPATH TO PLATEAU
PINK GRANITE TO WHITE MARBLE
WINDLESS CAMP TO WINDY CAMP
CAIRNS TO BEN MACDUI
MIST TO HORIZON
LOCH ETCHACHAN TO DERRY BURN
STEPPING STONES TO STRATH NETHY
BAD WEATHER TO SHELTER STONE
TAILWIND TO FAST GOING
PEAT MOSS TO SCREES
RAINCLOUDS TO RAINBOW
HAILSTORM TO WELLS OF DEE
BEGINNING TO END

EVERYTHING IS CONNECTED

RETROSPECTIVE
RANDOM
INTERCHANGES

LOCH ETCHACHAN TO TAILWIND
DESIRE TO MIDGES
WHITE MARBLE TO BEN MACDUI
END TO RAINCLOUDS
FULL MOON TO HORIZON
RAINBOW TO WALKING
STEPPING STONES TO DERRY BURN
WINDY CAMP TO MEMORY
CAIRNS TO BAD WEATHER
PLATEAU TO WINDLESS CAMP
MAP TO STRATH NETHY
HAILSTORM TO PEAT MOSS
SCREES TO FROGS
WELLS OF DEE TO SHELTER STONE
PINK GRANITE TO BEGINNING
FOOTPATH TO STONE CIRCLE
FAST GOING TO MIST

SCOTLAND 2007

Richard Long

One thing leads to another—Everything is connected, 2009
Various locations

Richard Long's work explores the relationships between time,
distance, geography, measurement and movement, as well as
between art and landscape. In the 1970s, he began making epic
solitary walks through rural Britain, as well as internationally. These
resulted in artworks, either in the form of sculptures made along the
way, photographs documenting them, or walks that became text
works. While he most often works directly in the landscape, making
discrete, reversible changes to the natural features he encounters,
he sometimes uses natural materials in the gallery environment.

One thing leads to another—Everything is connected, is a print
by Long that depicts the rugged landscape of the Cairngorm
Mountains in Scotland, which was traversed by the artist on foot.
It was produced as an edition of 60,000 and given away to London
Underground passengers at ten stations along the Jubilee line on
2 and 3 June, between 7am to 12pm. The environment described
in the artwork—by walking from place to place—contrasts with
the diverse cityscape through which the Jubilee line travels, from
Stanmore to Stratford.

The print was distributed at the following stations: Stanmore,
Wembley Park, Finchley Road, Baker Street, Green Park, Westminster,
London Bridge, Canada Water, Canary Wharf and Stratford. The
artwork was produced in partnership with Tate Britain to coincide
with the exhibition *Richard Long: Heaven and Earth*, a major survey
of his work held from June to September 2009.

Richard Long (born in UK, 1945) studied at the West of England
College of Art, Bristol and at St Martin's School of Art, London.
He has exhibited widely since his first solo show at the Konrad
Fischer Gallery in Düsseldorf in 1968. A leading exponent of Land
art, he represented Britain at the Venice Biennale in 1976 and was
awarded the Turner Prize in 1989 and the Praemium Imperiale from
Japan in 2010. His work is in major museum collections around
the world, including Tate, London; The Museum of Modern Art,
New York; Musee d' Art Moderne de la Ville de Paris and Museum
Ludwig, Cologne.

Previous pages
Richard Long, *One thing leads to
another—Everything is connected,*
2009.

Opposite
*One thing leads to another—
Everything is connected,* 2009, is
distributed across the Jubilee line
from 2–3 June, 2009.

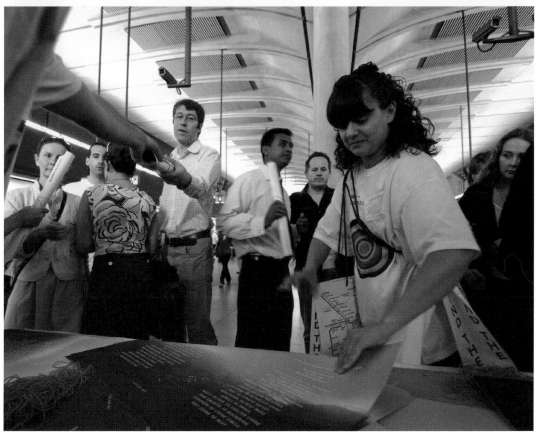

Dryden Goodwin

Linear, 2010
Various locations

Dryden Goodwin's work extends the limits of what portraiture can do. He often combines media, such as drawing, sound, photography and video. His multi-layered portraits convey a heightened sense of individuals or collective communities, and of how we interact with one another.

Goodwin's 60 pencil drawings of Jubilee line staff at work, or at moments of pause in their day, are each accompanied by a film of the portrait being made. The films include fragments of the conversation between artist and sitter, together forming an intimate and diverse social portrait of this community of workers.

Central to *Linear* is an acknowledgement of the inability of any portrait to describe a subject adequately. Rather than attempting to depict the hundreds of staff who work on the Jubilee line, *Linear* evokes a sense of their personal contributions through the detailed portrayal of just 60 individuals. A similar process of condensing occurs in each of the separate film portraits, where the real-time development of the drawings is speeded up and the conversations edited into intense (but inevitably incomplete) representations of each person. The investment of time becomes an underlying theme. This is emphasised in the captions accompanying the drawings, where the time taken to make each portrait is juxtaposed with the number of years the member of staff has worked on the Jubilee line.

The portraits were drawn in a variety of locations, including train operator's cabs, signalling towers, management offices, station control rooms, ticket offices and gates. Through the intertwining of these individuals' varied roles with the abundance of their personal revelations and experiences, different themes emerge encompassing life, death, love, personal obsessions and aspirations. In this way, *Linear* evokes both a physical and emotional mapping of the Jubilee line.

For Goodwin,

> Drawing someone you've never met before results in an intense encounter. For each drawing there's a unique imaginative space that I want to open up and invite people into. Because the drawings develop over time—people watch the process of the portraits being created on the page, so there is an investment of time, an exaggerated sense of things being revealed, both in the drawings and through what is said. *Linear* is about different types of connection.

Linear was presented across the London Underground network on poster sites, digital screens and leaflets, with exhibition locations

Dryden Goodwin, *Linear,* 2010.
Selection of 20.

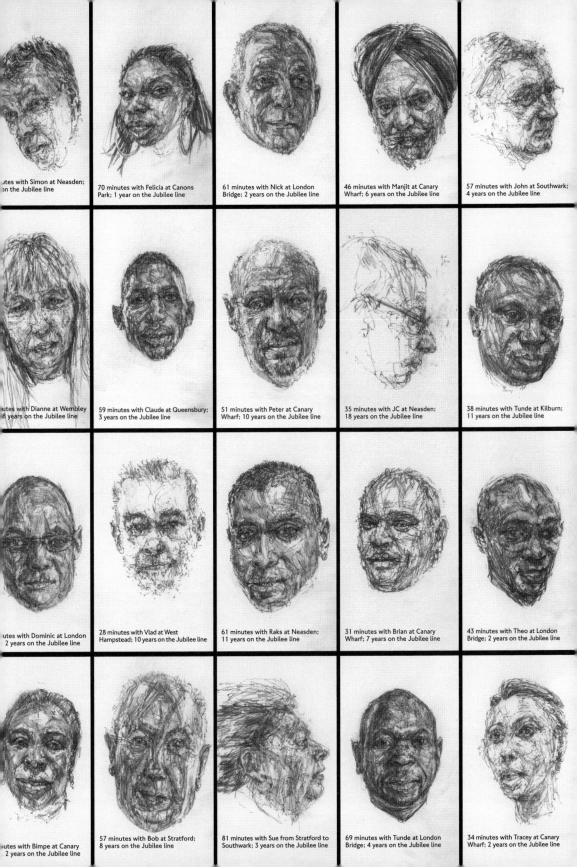

...utes with Simon at Neasden; ...n the Jubilee line

70 minutes with Felicia at Canons Park; 1 year on the Jubilee line

61 minutes with Nick at London Bridge; 2 years on the Jubilee line

46 minutes with Manjit at Canary Wharf; 6 years on the Jubilee line

57 minutes with John at Southwark; 4 years on the Jubilee line

...utes with Dianne at Wembley ...8 years on the Jubilee line

59 minutes with Claude at Queensbury; 3 years on the Jubilee line

51 minutes with Peter at Canary Wharf; 10 years on the Jubilee line

35 minutes with JC at Neasden; 18 years on the Jubilee line

38 minutes with Tunde at Kilburn; 11 years on the Jubilee line

...utes with Dominic at London ...2 years on the Jubilee line

28 minutes with Vlad at West Hampstead; 10 years on the Jubilee line

61 minutes with Raks at Neasden; 11 years on the Jubilee line

31 minutes with Brian at Canary Wharf; 7 years on the Jubilee line

43 minutes with Theo at London Bridge; 2 years on the Jubilee line

...utes with Bimpe at Canary ...2 years on the Jubilee line

57 minutes with Bob at Stratford; 8 years on the Jubilee line

81 minutes with Sue from Stratford to Southwark; 3 years on the Jubilee line

69 minutes with Tunde at London Bridge; 4 years on the Jubilee line

34 minutes with Tracey at Canary Wharf; 2 years on the Jubilee line

at Southwark, London Bridge and Stanmore Underground stations. Alongside this, all 60 films were available to view on the Art on the Underground website. Two years on and *Linear* serves not only as a tribute to the line's 30 years, but as a snapshot of a specific moment in time, made even more pertinent as many of those portrayed have changed roles or moved to work on other lines.

Dryden Goodwin (born in UK, 1971) studied at the Slade School of Art, London. Central to his practice is a fascination with drawing, often in combination with photography and video, as well as screen-based installations with accompanying soundtracks. Recent projects include a commission for *Who am I?* Gallery, Science Museum, London, 2010; the solo exhibition *Cast*, Hasselblad Foundation, Gothenburg, Sweden, 2009, and Photographers' Gallery, London, 2008; and the solo exhibition *Flight*, Chisenhale Gallery, London, 2006. Recent group exhibitions include, *Grand National*, Vestfossen Kunstlaboratorium, Norway, 2011; and *Who Gets to Run the World, British Contemporary Art*, Total Museum, Seoul, South Korea, 2009, and Hanjiyun Contemporary Space, Beijing, China, 2009. He has also exhibited at Tate Modern, Tate Britain and the Venice Biennale. Works in public collections include, The Museum of Modern Art, New York, The Tate Collection and The National Portrait Gallery, London.

Below, Opposite and Overleaf
Linear installed at various locations across the network, including Southwark and Stanmore Underground stations, 2010.

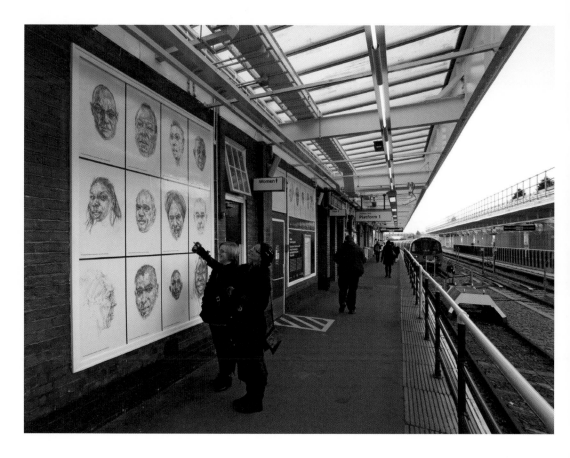

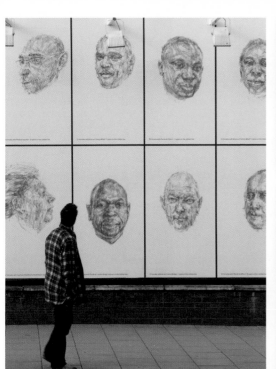

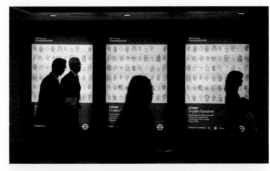

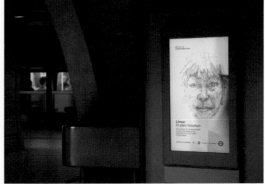

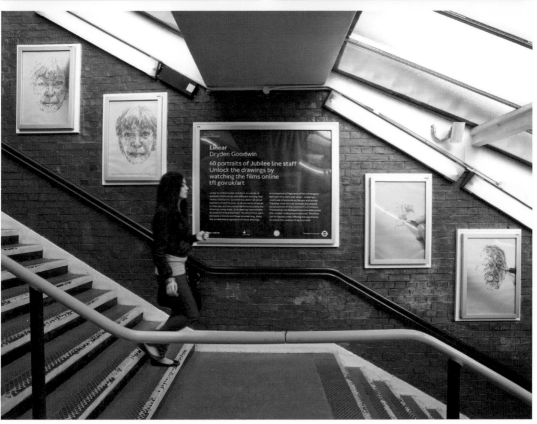

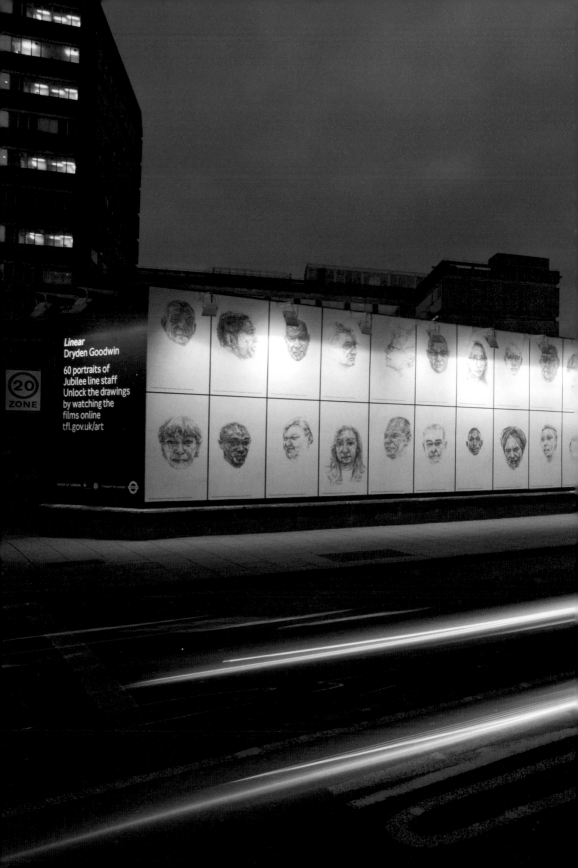

Linear
Dryden Goodwin

60 portraits of
Jubilee line staff
Unlock the drawings
by watching the
films online
tfl.gov.uk/art

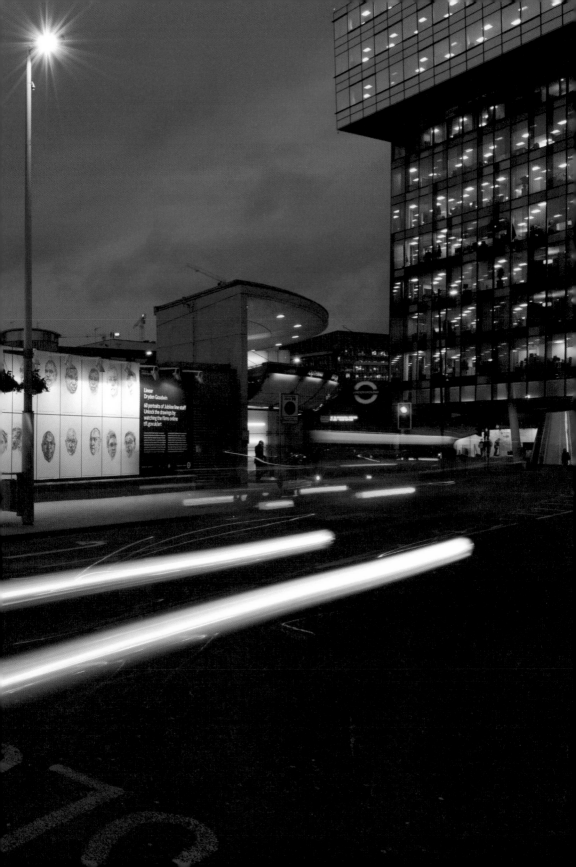

Interview Quotes

Ashanti

I've done all sorts of shifts, nights and day, anything. The office hours would have been good for me but I can't have it, whatever they give you, just take it and well today dead early, used to it, sometimes I have to get up early in the morning, going to station, to open up the station at four. That was really tough. I think I'll be finishing… this October I think. I'm retired. I'm retired. I'm only doing part time now. I don't know yet. Yeah. I don't know. This part time has just helped me so staying at home and looking at the four walls, it keeps me going on, I'm glad for that.

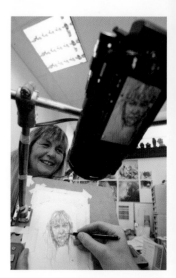

Tracey

Within the first year of me working here a gentleman come down the escalator, had a massive heart attack, dropped dead, smashed his face off the PED doors. 40 minutes before an ambulance service got here and 30 minutes we was trying to do CPR, save this guy's life. He ended up dying and it was just before Christmas and it hit me pretty hard, not because, I mean he wasn't really an old guy and he was quite fit and everything, but it was just the fact that it was coming up to Christmas and he died and I'm sitting there thinking, God I can't let this man die. I held his hand, it was, it was really awful, but I held his hand because, and I said to the police when they was like taking our information, I went please just let his family know he didn't die by himself. That someone held his hand and talked to him and said his name, because I do not want them to think that their father, their husband, their brother died on an empty platform with people all around him and no one caring. I was 17 when I had my daughter. Teenage mum… .

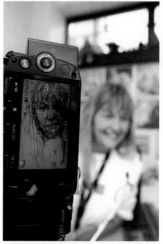

Tunde

Did you hear the screaming?
 Yes. They say, you know, mother and baby were OK. The female paramedics was the one that carried the baby. I carried one of the bags. The sister and the male paramedics helped the mother out into the ambulance waiting on the High Street. Then phoned round about, maybe 10.10 or so, phoned service manager, well baby's been born, it's a girl. I say ah well, I think we'll name her Baby Jubilee so, and that's how anytime we speak it's like Baby Jubilee.
 Thank you.
 This is your life.
 This is your life.

George

Longevity is, in the job, it's highly prized. You can, you're not really taken seriously until you've been around for at least ten years. My first job on London Underground was as a railman. I used to do the cleaning on the Bakerloo line.

Goodwin drawing portraits of Jubilee line staff and quotes from the artist's staff interviews from the films.

Chulani

It's important to be really relaxed you know. Meditation and feel really philosophical otherwise, you meet so many different characters on this job that you have to be, your people skill, oh they've got to be extremely good, get on otherwise, you know....

When I first joined the Underground, I was brought up strict, strict upbringing, very disciplined, I had to do all the studies, we learnt to get on because the family was big, culture side, music, sports, came onto the Underground and tried to be very gentleman and it didn't work because the characters you get here and the terminology they use and all that completely different you know. Actually I was too sensitive for this environment you know, this is a harsh environment. So I had to adapt....

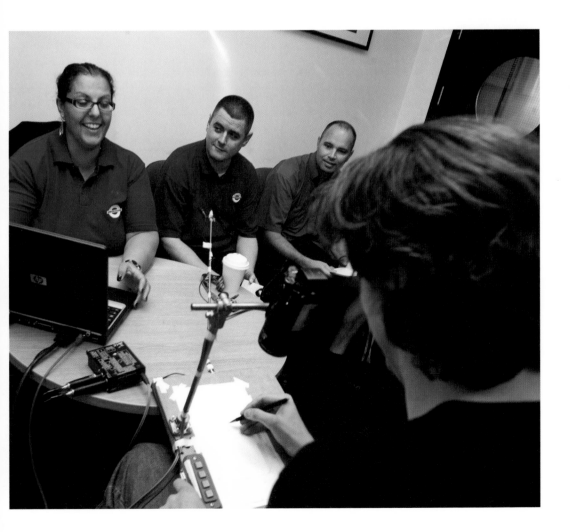

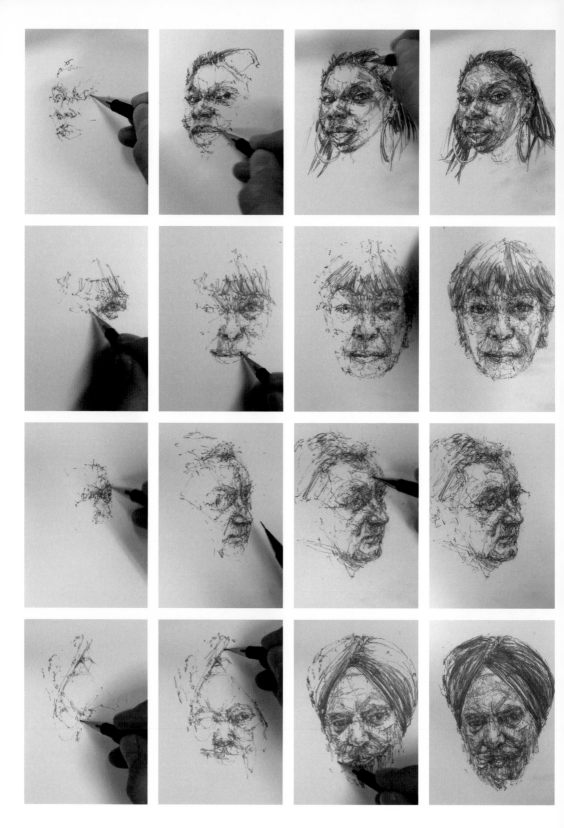

The origins of *Linear* stretch back to an artist's residency in 2003 at Lacock Abbey, where the archive of the photography pioneer Henry Fox Talbot (1800–1877) is housed, I was shown blank parchments that were all that remained of some of his earliest photographic exposures. They had completely faded. The archivist described a chemical process able to bring these images back into being, called "reviving". This notion propelled me to think about the idea of reactivating or unlocking something that is lost or hidden. Like a time capsule, the films for *Linear* allow the possibility to reanimate, even resuscitate, the drawings, and also to revive the brief relationships that I formed with each sitter.

When I look at a drawing by other artists such as a portrait by Giacometti or a landscape by Cézanne, or a photographic experiment by Fox Talbot, I find myself speculating as to what may have happened beyond the frame, surrounding and during the moment of making the work. What were the experiences and circumstances that the artist decoded and translated into the image.

When I look at my own drawings from the past, they act as triggers to the circumstances in which they were made: the details of memory, the people I was with, the weather, fragments of atmosphere and emotional charge are opened up. When making the films in *Linear*, what intrigued me was the desire to involve the viewer more fully in travelling back in time, to the moments of the encounters themselves, opening up other dimensions of these shared experiences. There is an opportunity partially to unlock the atmosphere and dynamics of the setting for each of the static portraits. Many aspects and subtleties of these interactions are still concealed and distorted, but I like that these absences can become active spaces in the imagination. In *Linear*, each image unfurls gradually, like a long photographic exposure.

Dryden Goodwin, December 2011

Dryden Goodwin, *Linear*, 2010.
Selection of 16 film stills sequences.

Nadia Bettega

Threads, 2010
Charing Cross and Kingsbury Underground stations

Nadia Bettega has a background in Psychology and Health Research, and now works as a freelance reportage and portrait photographer. She has been involved in a wide variety of projects, working with asylum seekers, refugees and BME youths in the UK. She is a founding member of Eyes Wide Open, a community partnership running participatory photography projects and aimed at facilitating creativity, innovative thought and talent in often marginalised groups.

Threads draws inspiration from the common expression, "Travel expands the mind". Young people from Brent Youth Inclusion Programme set out from their local Underground station, Neasden, to join Bettega on a week-long journey to explore portraiture and place through photography. Together they visited significant places in Brent, located along the Jubilee line, including Wembley Park station and Wembley Stadium.

Participants kept a daily journal in which they developed their ideas about the different people who might work at, or visit, each location. Building upon this, each participant then 'acted out' his or her own imaginary character in front of the camera and Bettega recorded their reflections on the day.

The group also visited exhibitions by international artists and photographers at Camden Arts Centre near Finchley Road Underground station and The Photographers' Gallery in central London, to develop their knowledge of portraiture.

Bettega produced a series of photographic portraits that were exhibited at Kingsbury and Charing Cross Underground stations and The BAR Gallery, Willesden Green Library. The photographs reflect the variety of responses within the group to a single place at a specific moment in time, and also chart each individual's creative progress across the week.

Threads was a collaboration with the Brent Youth Inclusion Programme, a Brent Council programme.

Nadia Bettega (raised in Zambia) studied at University College London. She is a freelance photographer with an interest in using the medium in co-productions with local communities. Much of her work centres around awareness-raising and advocacy, ranging from supporting projects with asylum seekers, refugees and young people from black and ethnic minorities to delivering educational projects for The Photographers' Gallery, London. Nadia recently completed a commission for the British Institute of Human Rights (BIHR). She has also collaborated with The Diana, Princess of Wales Memorial Fund and the US President's Emergency Plan for AIDS Relief (PEPFAR) in Cote D'Ivoire.

Nadia Bettega, *Threads*, 2010
"I stand straight, arms folded. I am listening to a conversation and looking after people."

Overleaf
Nadia Bettega, *Threads*, 2010.
Selection of portraits.

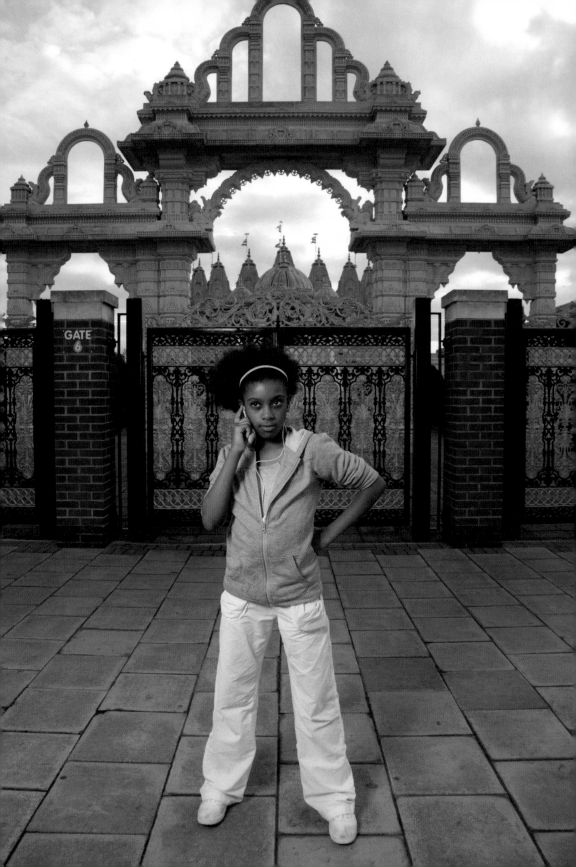

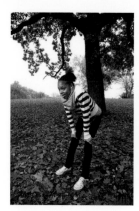

"I get up at 6.30 every morning, to jog for at least 30–40 minutes."

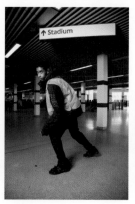

"I have worked here for over ten years and support my family by maintaining the station. I work with my shovel and clear away the rubbish."

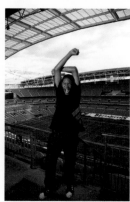

"I feel nervous, but then when the whistle blows I realise we have won the match!"

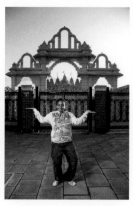

"We celebrate ceremonies here and pay respect to our Gods."

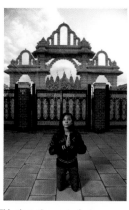

"My place of prayer is silent, detailed and calm, it makes me feel at peace."

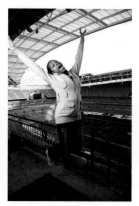

"I'm screaming and cheering energetically because my team have won."

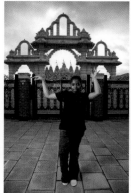

"I take off my shoes as I enter this place of prayer, it's detailed and holy inside. I'm a dancer."

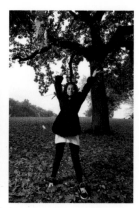

"I come here to play and have fun with the autumn leaves and my three siblings."

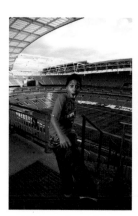

"I'm van Persie, play with my left foot, I imagine dribbling and passing the ball… I take the shot!"

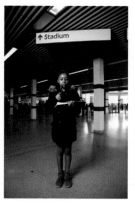

"I have my note pad and write in my book. I make sure everyone does their job."

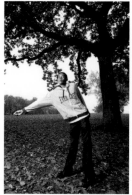

"I'm a dog walker, although he's ended up walking me, instead of me walking him!"

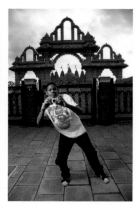

"I have visited London for over 12 years and it's the first time I have seen a temple like this!"

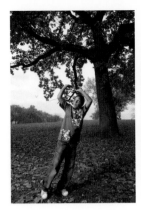

"I dribble, jump, leap and shoot! I then slam dunk and go past all the other players in the park. Yeahhh!"

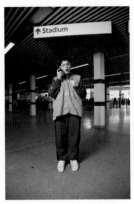

"I tell the rest of the team what they need to do. It's an important job!"

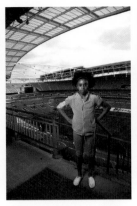

"I'm a player, I think of something that makes me happy…and then I focus on the game."

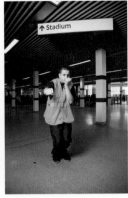

"I have been doing this job for 20 years—I pull the lever to get the train moving."

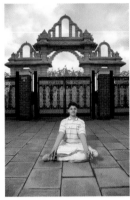

"I come here to pray and reflect. I live a simple life."

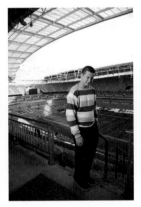

"I'm upset because my team has lost the match…and it was an important one."

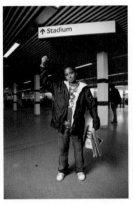

"On my way to a business meeting. If I seal this deal, I am going to raise my bonus!"

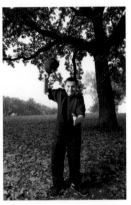

"I am kind and have lived a long life. I lift my hat with respect as I greet people I meet in the park."

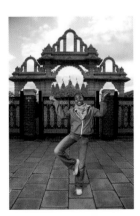

"Meditation and yoga are part of our lives. I pray for several hours each day, this gives me time to reflect."

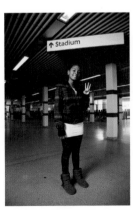

"You have to be friendly and get to know the passengers… don't be shy but smiley."

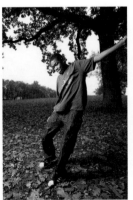

"I'm playing football, heading the ball, going for a free kick!"

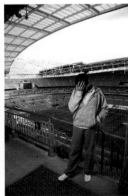

"I'm upset and disappointed because my team is losing.… Why didn't my team do better?"

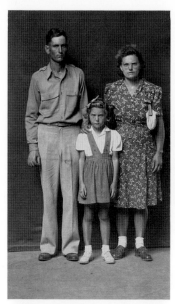

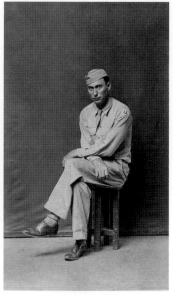

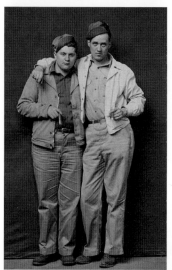

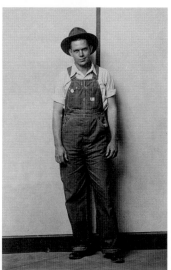

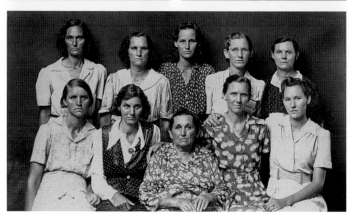

Michael Disfarmer, untitled, undated.

Michael Disfarmer (1884–1959) was a great American portrait photographer, and was often described as something of a mystery. Very little is known about him, or many of his subjects. Disfarmer set up a small-town photography studio in Arkansas, enabling anyone from the surrounding countryside to get their pictures taken. His life's work evolved through a democratic process—anyone from the mayor to the paper boy could have their photograph taken—and it preserved a culture of the past. It triggered my curiosity.

In looking at Disfarmer's work, I often tried to imagine who each of the people in the photographs were, what they did, where they came from and how far they had travelled to have their portrait taken. I drew on this when thinking of the *Threads* project, as I wanted the participants to use their imagination whilst they travelled and created their characters. The project was democratic because all of their ideas—who they would become, what they would do— were considered. I hope that audiences on the Tube also had their curiosity triggered about each young person featured.

Nadia Bettega, January 2012

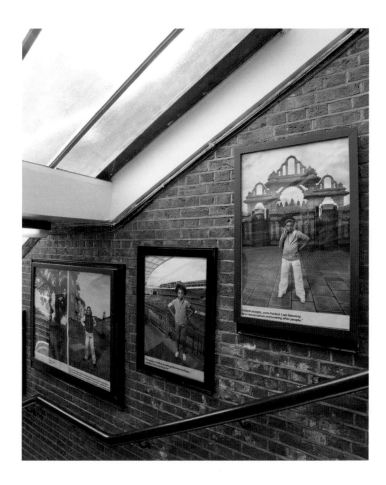

Nadia Bettega, *Threads*, 2010.
Kingsbury Underground station.

John Gerrard

Oil Stick Work (Angelo Martinez/Richfield, Kansas), 2008
Canary Wharf Underground station

As part of the Jubilee line series, artist John Gerrard presented his work *Oil Stick Work (Angelo Martinez / Richfield, Kansas)* 2008 as a large-scale projection (8 x 12m) on a monolithic block wall in Canary Wharf Underground station's ticket hall over the course of one year.

Oil Stick Work is a complex digital moving-image work that develops in real time for a 30 year period. Beginning in 2008 and continuing until 2038, the work presents an immersive landscape constructed from 'real' information (digital photographs and topographies of an existing American agricultural landscape) mapped onto meticulously constructed 3-D forms. The central focus of the landscape is an industrial grain silo. Commuters to and from Canary Wharf were invited to enter this virtual scene exactly three years into the slowly unfolding story of the work.

Oil Stick Work is the first in a series deriving from Gerrard's research into one of America's greatest environmental catastrophes, the American Dust Bowl of the 1930s. This phenomenon was caused by ten years of intense post-war wheat farming over an area of one million square miles. This mass intervention, enabled by the power surge from the new resource of petroleum, proved catastrophic once the cyclic droughts in the regions returned. Newly unstable topsoil began to blow, forming a series of vast dust storms that choked the landscapes and populations, in what is still the worst environmental tragedy in US history.

The interwoven stories of nitrogen fertilizer, crops and oil are the threads of a dark narrative hovering behind capitalist society that Gerrard unveils through the constellation of four works, also including *Dust Storm (Dalhart, Texas)* 2007, *Grow Finish Unit (near Elkhart, Kansas)* 2008 and *Animated Scene (Oil Field)* 2008. Together, they outline the growing geopolitical storm on the horizon.[1]

Oil Stick Work is the only one of the series to feature a human being, albeit an entirely animated 'version' of a human being. The eponymous Angelo Martinez was photographed as a real person and translated into polygons via a complex body-mapping and scanning process used primarily in the gaming industry. Over the course of his 30 year existence, Angelo arrives for work every day at dawn (CST) and departs at sunset. His daily task is to paint an exact and perfect one metre square of the grain silo using an artist's oil stick. During the three-decade life of the work, he will slowly and painstakingly paint the entire building, forming a dark silhouette in the heart of this virtual landscape. Visitors to the work were able to see his gradual progress over the course of the year that the work was on show at Canary Wharf.

Opposite
John Gerrard, *Oil Stick Work
(Angelo Martinez/Richfield,
Kansas)*, 2008. Selected stills.

Overleaf
John Gerrard, *Oil Stick Work
(Angelo Martinez/Richfield,
Kansas)*, 2008. Canary Wharf
Underground station.

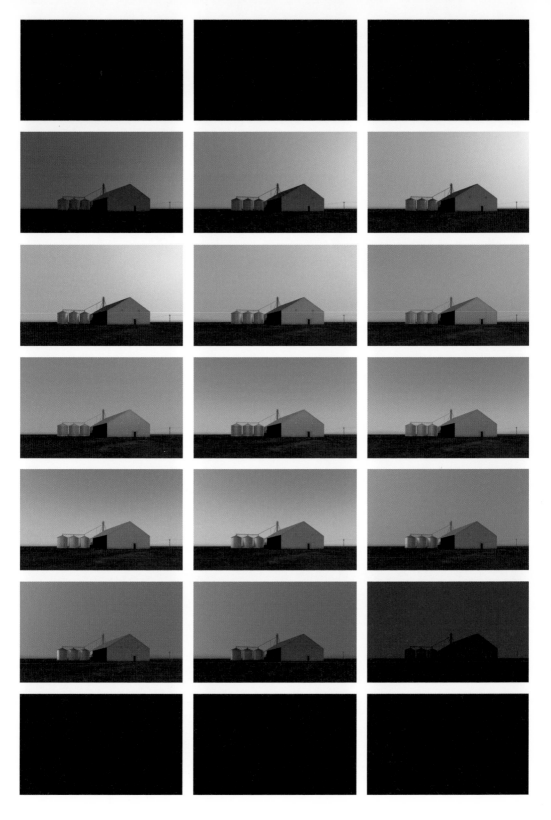

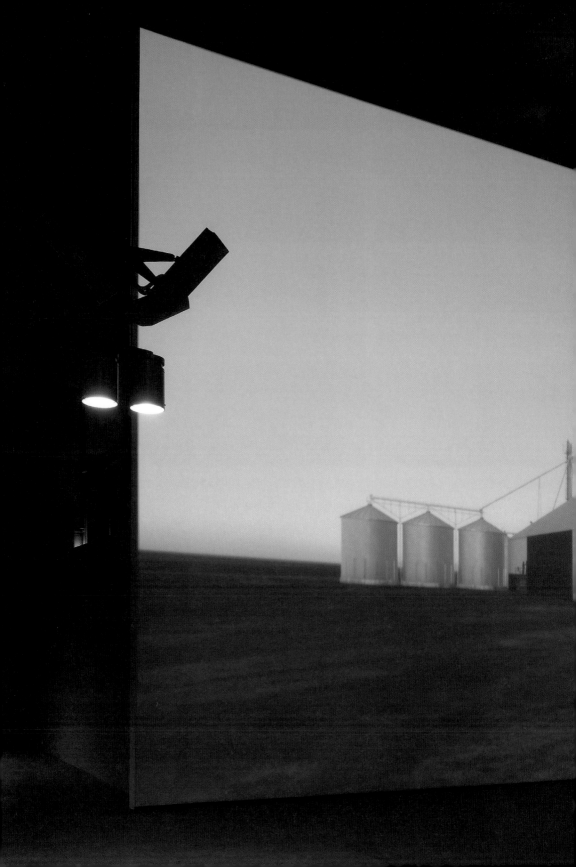

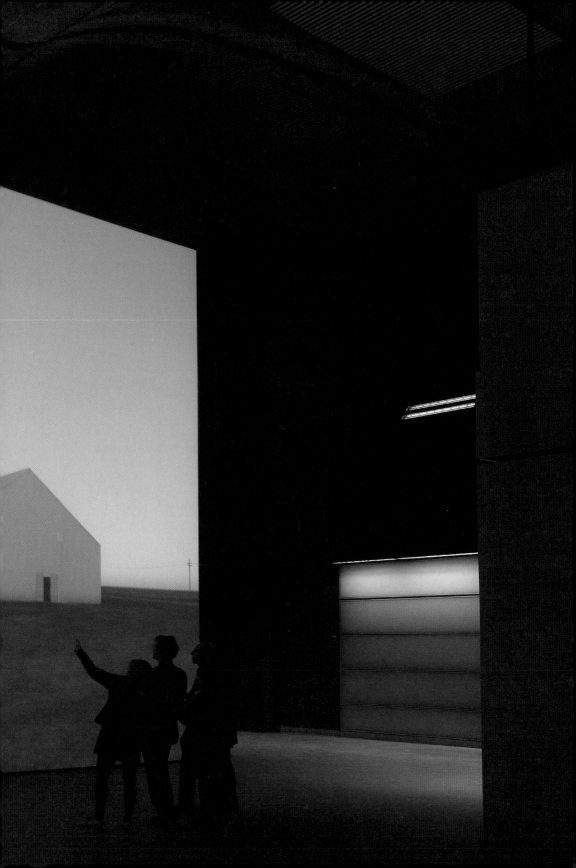

Inserted into the vast Docklands complex, Angelo was transported to the other end of the economic scale, where his labours were juxtaposed with Canary Wharf's virtual worlds of stocks and shares. Located at the far end of the ticket hall, the work offered a metaphorical departure into a landscape that was a reminder of the 'realities' of the activity above ground.

John Gerrard (born in Ireland, 1974) has a BFA from The Ruskin School of Drawing and Fine Art, Oxford University. He undertook postgraduate studies at The School of The Art Institute of Chicago and Trinity College, Dublin. Recent solo presentations of Gerrard's work include *Infinite Freedom Exercise*, Manchester International Festival, Manchester, UK, 2011; *John Gerrard*, Perth Institute of Contemporary Art, Perth, Australia, 2011; *Universal*, Void, Derry, 2011; *John Gerrard*, Temple Bar Gallery and Studios, Dublin, 2008; *Dark Portraits*, hilger contemporary, Vienna, 2007; and Royal Hibernian Academy, Dublin, 2006.

1 For the 53rd Venice Biennale, the four works were presented collectively as *Animated Scene*. *Dust Storm (Dalhart, Texas)* 2007 is a reconstruction of the original dust cloud, uncovered by Gerrard in a sepia photograph taken in Stratford, Texas, in 1935. This photograph was reproduced as a moving digital animation (using footage of dust storms from Iraq) as an entirely digital manifestation that slowly engulfs the landscape. *Grow Finish Unit (near Elkhart, Kansas)* 2008 takes the viewer on a slow perambulation around a robotic pig-manufacturing unit (an unmanned farm). The somnambulant oscillation of the 'camera' (if this were a film) drifts over the lake of effluence that flows from the unit—the only 'living' sign of any occupation—and glides past the facades of ten desolate-looking single-storey barns containing the pigs. *Animated Scene (Oil Field)*, the last of the four works, portrays the plodding rhythmic nod of an oil derrick, again entirely unmanned, relentlessly sapping an oil seam far below the surface of the scarred earth.

Top
Research image from the Centre for American History, University of Texas at Austin.

Bottom
John Gerrard, *Dust Storm (Dalhart, Texas)*, 2007.

Daria Martin

Jubilee line customer daydream survey, 2011
Various locations

Daria Martin's work combines elements of film, painting, sculpture, performance, dance, and music. She is well known for creating films that in some sense perform interior mental states. Her interest in film lies partly in the tension created between the medium's ability to describe form and space, and its failure to actually embody material volume. She draws a parallel between this space of uncertainty and the indefinite space of psychological projection. Past works have explicitly addressed dreaming or daydreams: *Harpstrings and Lava,* 2007, attempts to render a friend's childhood nightmare through clashing surfaces and spaces, while *One of the Things That Makes Me Doubt,* 2010, dramatises her late grandmother's decades of dream diaries.

Travelling underground, or spending any length of time there, is not a natural human inclination. In her work *Jubilee line customer daydream* survey, Martin sought to discover to what extent passengers' travelling on the Tube use self-imposed psychological tricks and 'daydreams' as a distraction from the reality of being under the ground. It seems that one thing people do is to mentally transport themselves elsewhere, into the realms of fantasy. Using a questionnaire designed in the 1970s by the psychologist Auke Tellegen, and adapted for her project, Martin conducted face-to-face surveys with 800 passengers at ten different Jubilee line stations during early 2010, in order to uncover their susceptibility to 'absorption', or getting wrapped up in their own inner worlds and subjective perceptions.

Martin also visited the Freud Museum, based near Finchley Road Underground station on the Jubilee line, and took photographic images of the objects on the psychoanalyst's desk. A selection of the varied responses to the questionnaire and to Martin's simple question "What have you been daydreaming about on the Tube?" were combined with the images of the objects from the Freud Museum to make a series of poster-based artworks, which were presented across the Tube network and an online collection of customers' daydreams.

Jubilee line customer daydream survey presents the fleeting images of people's daydreams *en masse* as a way of revealing the surprising, and sometimes critical, perspectives people have of the city they inhabit and the roles they perform within it.

Daria Martin (born in USA, 1973) studied Humanities at Yale and received her MFA from the University of California, Los Angeles, in 2000. She has had solo exhibitions at venues including the Milton Keynes Gallery, 2012; Museum of Contemporary Art Chicago, 2009, which toured to the New Museum, New York, and the Hammer Museum, Los Angeles; Stedelijk Museum, Amsterdam, 2006; Kunstverein Hamburg and Kunsthalle Zurich, both 2005.

Daria Martin, *Jubilee line customer daydream survey,* 2011.

ART ON THE
UNDERGROUND

"Finding myself
having David
Lean's house
on the Thames,
having an indoor /
outdoor party there.
A treasure hunt,
Latin dancing,
al fresco eating
and fireworks. All
filmed and released
at Cannes."

1 of 800 daydreams reported by
Jubilee line customers in a recent survey

Tell us your daydreams
art.tfl.gov.uk

Image: Detail of object on Sigmund Freud's
desk. Courtesy Freud Museum London.

MAYOR OF LONDON LOTTERY FUNDED FREUD MUSEUM LONDON Transport for London

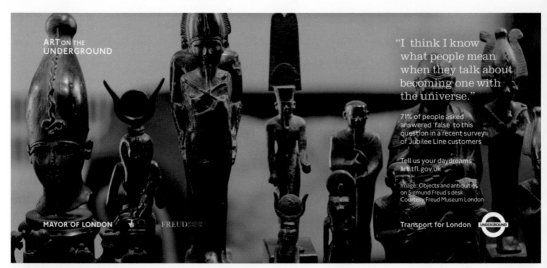

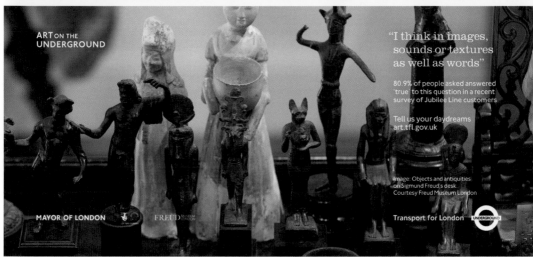

Daria Martin, *Jubilee line customer daydream survey*, 2011. Selection of posters displayed on the network.

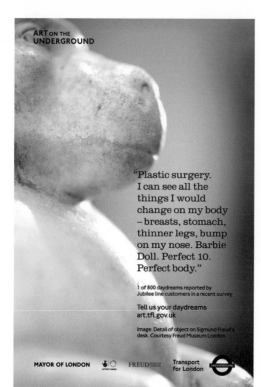

"Plastic surgery.
I can see all the
things I would
change on my body
– breasts, stomach,
thinner legs, bump
on my nose. Barbie
Doll. Perfect 10.
Perfect body."

1 of 800 daydreams reported by
Jubilee line customers in a recent survey

Tell us your daydreams
art.tfl.gov.uk

Image: Detail of object on Sigmund Freud's
desk. Courtesy Freud Museum London

MAYOR OF LONDON FREUD MUSEUM Transport
for London

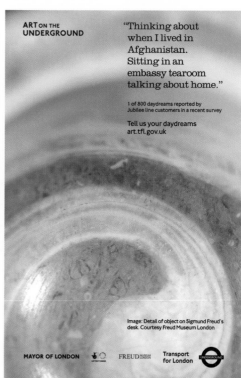

"Thinking about
when I lived in
Afghanistan.
Sitting in an
embassy tearoom
talking about home."

1 of 800 daydreams reported by
Jubilee line customers in a recent survey

Tell us your daydreams
art.tfl.gov.uk

Image: Detail of object on Sigmund Freud's
desk. Courtesy Freud Museum London

MAYOR OF LONDON FREUD MUSEUM Transport
for London

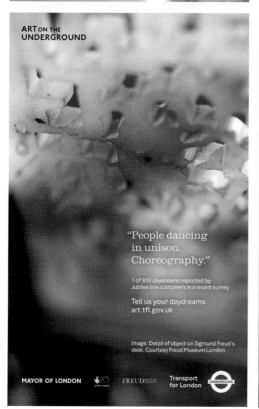

"People dancing
in unison.
Choreography."

1 of 800 daydreams reported by
Jubilee line customers in a recent survey

Tell us your daydreams
art.tfl.gov.uk

Image: Detail of object on Sigmund Freud's
desk. Courtesy Freud Museum London

MAYOR OF LONDON FREUD MUSEUM Transport
for London

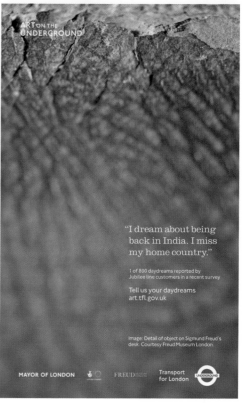

"I dream about being
back in India. I miss
my home country."

1 of 800 daydreams reported by
Jubilee line customers in a recent survey

Tell us your daydreams
art.tfl.gov.uk

Image: Detail of object on Sigmund Freud's
desk. Courtesy Freud Museum London.

MAYOR OF LONDON FREUD MUSEUM Transport
for London

Left
Passengers participating in the *Jubilee line customer daydream survey*, 2011.

Right
Selection of Jubilee line passengers' daydreams.

earlier in the day I was in a queue at the bank. The man in front of me was having his house re-posessed and on the Tube later I was daydreaming about finding a way to help him, even though he was a total stranger

Being able to talk English fluently and being able to speak all languages, communicate with everyone in the universe

being a superhero / superman. Being able to fly through cities—seeing the world—freedom

Thinking about adverts seen on my journey. Scenery adverts / beach mountain. Images of travel

I think about the homes and gardens and people that live there as I pass

being in some sort of army situation, modern, guns, running around and manic

thinking about my parents. I always used to travel with them

I'm not really day dreaming at the moment. A friend died this week and whenever my mind isn't busy that's what comes to mind

when my mum was alive. She was so special and spiritual

my granddaughter. I dream about what she will grow up like and be. I just think of babies and baby things at the moment. I'm going to see her. One week old

thinking about my teenage son. What will he do and what university will he go to. What type of girl will he marry

daydreaming about a boy

dreaming of getting back with ex. Reunion

sweet memories

summer. Sea. Sand. Sun. parties and bikinis and a turquiose sea

travelling to open and clear spaces. Bright and sunny days

red ferrari. Summer night. Convertible. Speed. Music

blank clouds

Daydreaming on the Tube

Station location:

Date:

Hello.

Could I ask you about tube travel and day-dreaming?

It's for London Underground and will take less than 4 minutes.

Interviewer Instruction: Then, if necessary/you are asked "why" say: It's for the Art on the Underground scheme, to generate information for an artist we have commissioned.

And also, if necessary to reassure: We won't be taking your name or any personal information so what you say will be totally anonymous.

I will ask you a few basic questions first as a warm up, and then some more interesting ones.

1. Where are you traveling from?

2. To?

3. What do you do for a living?

Now for some more interesting questions.

Please answer with "true" or "false" to the following five statements. Don't think about it too much just give a quick response.

4. Beautiful language can move me to tears.

5. When I watch a good movie, I feel as though I become a part of the action.

6. I like to watch the flickering flames of a fire.

7. I think I know what people mean when they talk about becoming one with the universe.

8. When I listen to music, I tune out the outside world.

9. It is easy for me to imagine the sensation of flying.

10. I can see auras.

11. The sound of a babbling brook stimulates my imagination.

12. I have been overwhelmed at the sight of a work of art or architecture.

13. Certain music makes me feel as though I am floating or flying.

14. The sound of wind through tunnels can be as interesting as music.

15. Certain smells bring me right back to childhood.

16. I'm sometimes convinced that I know a person, even though I haven't met them before.

17. After dancing, my body often feels as if it's still dancing.

18. Images appear in my mind's eye spontaneously.

19. When people describe their inner child, I know what they're talking about.

20. I feel that my sense of self is fluid.

21. The words 'surreal' or 'hyperreal' describe experiences I have on a regular basis.

22. I think in images, sounds or textures as well as words.

23. The sight of the horizon excites me.

Finally, I would like you to turn your mind's eye to your most recent daydream, perhaps one that you experienced on today's travel on the tube.

Can you choose a picture or pictures from amongst this group that would best illustrate your most recent daydream?

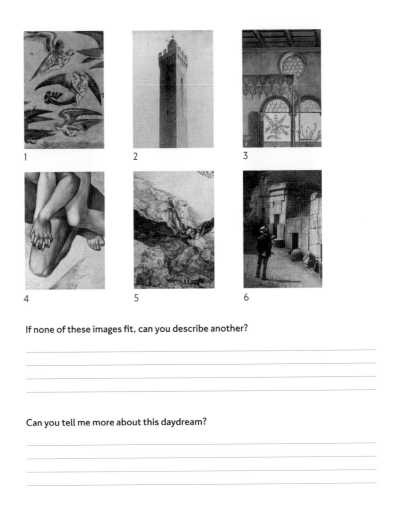

If none of these images fit, can you describe another?

Can you tell me more about this daydream?

This questionnaire, based upon one designed by Auke Tellegen in the 1970s, was used to survey passengers on the Jubilee line in early 2011.

Matt Stokes

The Stratford Gaff: A Serio-Comick-Bombastick-Operatick Interlude,
2010, Stratford

Matt Stokes' artistic practice is driven by an interest in discovering what unites communities in a particular place and how these connections evolve in response to specific events or moments. Through collaborations with people and groups, he produces films, installations and events. Recent projects have involved working with extreme metal vocalists, musicians and fans of the punk scene in Austin, Texas, and drawing together the historical and contemporary worlds of folk music in the Northeast of England and Camden Town, London.

The Stratford Gaff: A Serio-Comick-Bombastick-Operatick Interlude brought together a diverse group of performers to create a vibrant film installation at Stratford station. As its title suggests, the work draws on the East End's rich history of popular entertainment, theatre and cinema. It offers viewers a contemporary take on the Victorian 'Penny Gaffs', notorious temporary theatres that often sprang up in areas inhabited by costermongers and other street traders. For a penny, audiences were entertained by quick-fire performances including comic songs, dances, music, acrobatics and short plays.

The installation included a long wall displaying portraits and playbills, designating an area for entertainment. The *Gaff* itself came to life via three large screens, on which the players perform their acts, accompanied by a 'house band'. Reflecting the busy life of the station, each show lasted only a few minutes and offered regular travellers a chance to see a different performance on every journey.

Stokes' project for Stratford began with research into the area's local history. Stratford's importance as a trading centre grew in the nineteenth century, assisted by rapid industrialisation and expanding transport networks. Its population increased, and with this, the demand for affordable entertainment. As the East End became known for its Penny Gaffs, several licensed theatres soon opened in Stratford, including the Theatre Royal in 1884. With the advent of film, the appetite for live performance dwindled, and many theatres were transformed into cinemas. The Theatre Royal did survive, however, thanks to the efforts of Joan Littlewood's critically acclaimed Theatre Workshop, which took up residence there in 1953.

From this historical starting point, Stokes developed the initial idea for his work, but it was through informal meetings, chance

Matt Stokes, *The Stratford Gaff:
A Serio-Comick-Bombastick-
Operatick Interlude*, 2010.
Portrait of Charlie Seber.

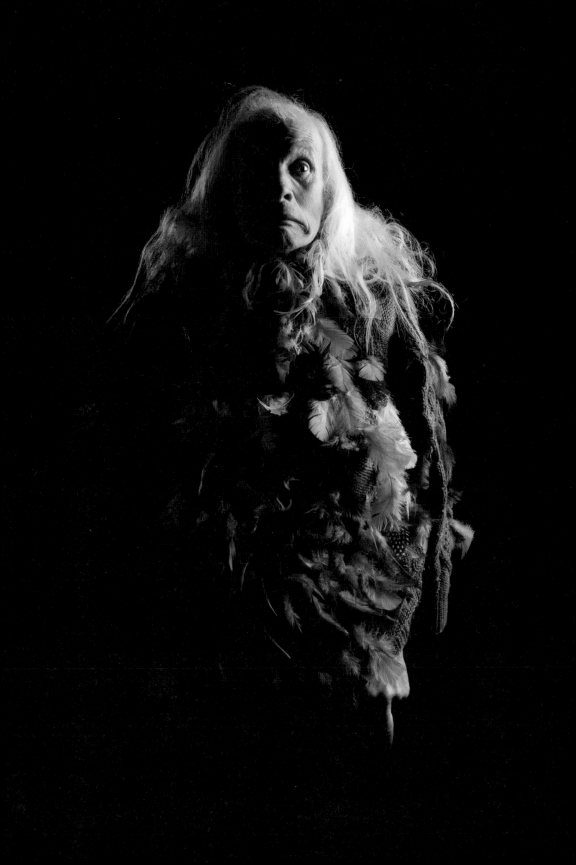

encounters and recommendations from the people of Newham that *The Stratford Gaff* truly came alive.

Matt Stokes (born in UK, 1973) studied Fine Art at Newcastle University. His solo exhibitions include *Nuestro tiempo/Our Time*, Centro Andaluz de Arte Contemporáneo, Seville, 2011; *The Distant Sound*, De Hallen, Haarlem, 2011; *No Place Else Better Than Here*, Kunsthalle Fridericianum, Kassel, 2010, and these are the days, Arthouse, Austin, 2009. In 2006, he was the winner of the Beck's Futures Prize.

Matt Stokes, *The Stratford Gaff: A Serio-Comick-Bombastick-Operatick Interlude, 2010.* Installation at Stratford Underground station.

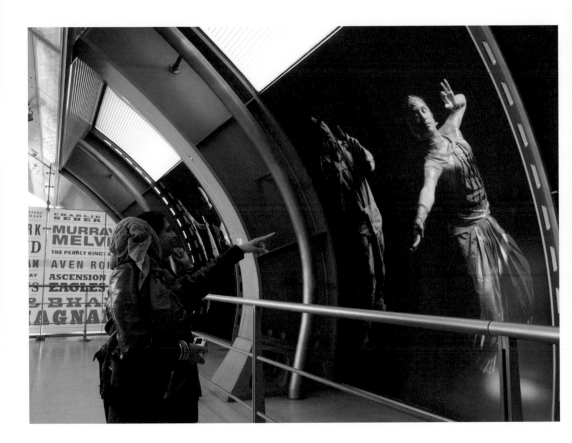

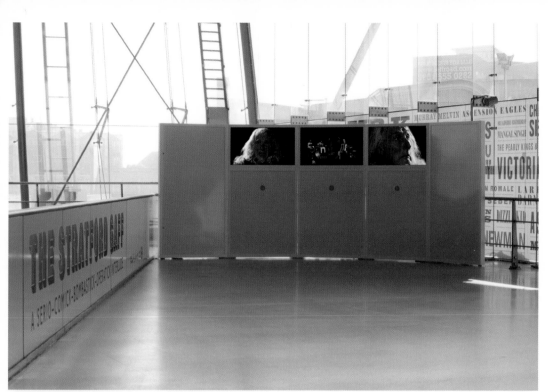

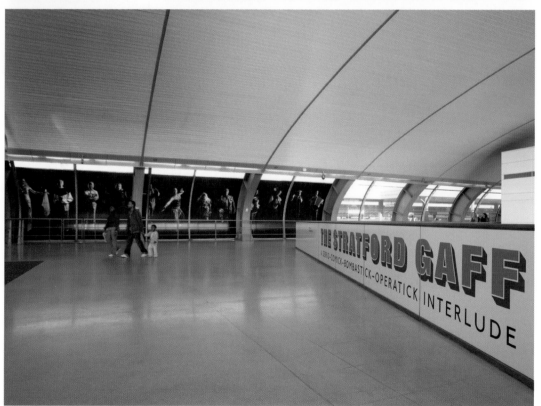

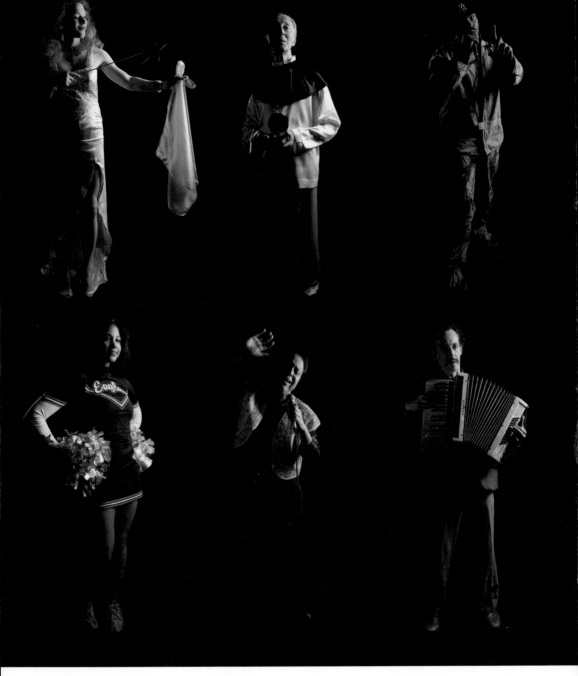

Victoria Elizabeth Day
Magician and female impersonator,
entertaining with puns and tricks

Ascension Eagles
British champion cheerleaders,
presenting a variety of acrobatic stunts

Murray Melvin
Actor and member of Theatre
Workshop's original production of
"Oh What a Lovely War" performing
"When this Lousy War is Over"

Mangal Singh
Bollywood singer, performing the
popular song "Rail Gaddi"

Dizzle Kid
UK music artist 'Lava u init', presenting
"RADIO 1"

Aven Romale
A collective of the finest Romany
and jazz musicians, providing musical
accompaniment

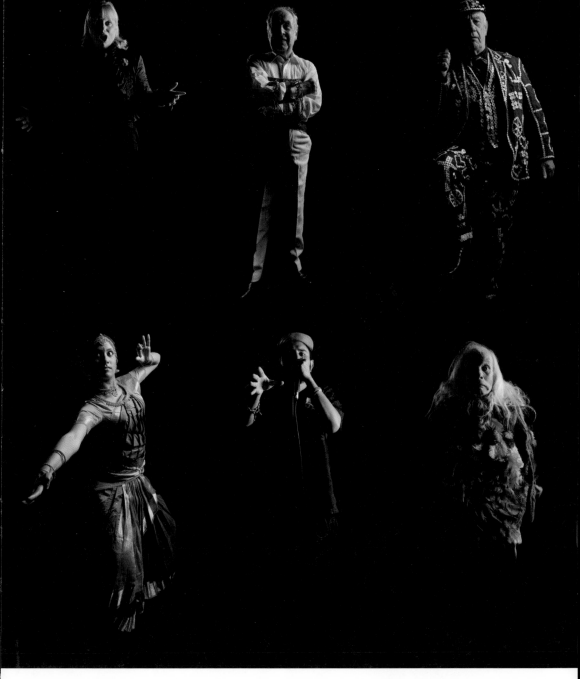

Sovra Newman
Soprano, singing the classic song "I'm Forever Blowing Bubbles" by J Kenbrovin & J W Kellette, 1919

Kali & Bhanu Kanthagnany
Dancing to the song "Thodaya Mangalam"

Larry Barnes
Escapologist, magician and music-hall performer, presenting his "Bedlam Jacket" routine

Mr K
Beatboxer, freestyling an eclectic mix of bass-lines and sounds

The Pearly Kings & Queens
with the Pearly King of Newham, singing "The Barrer Boy Song"

Charlie Seber
Comedian, rapping a surreal account of life as a fledgling owl

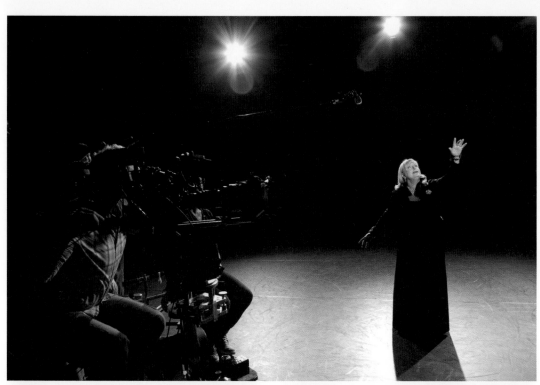

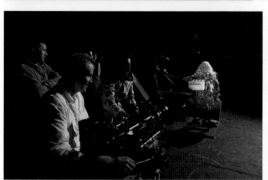

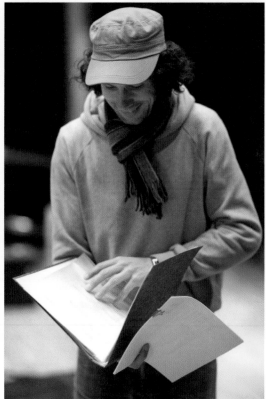

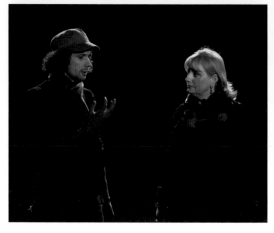

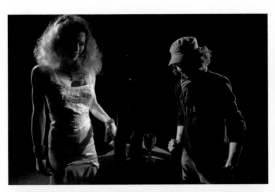

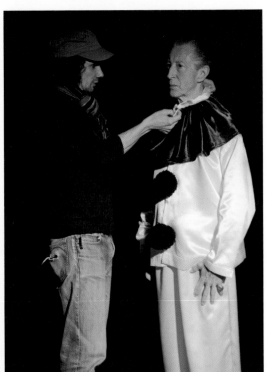

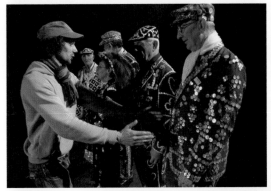

"In many of the thoroughfares of London there are shops which have been turned into a kind of temporary theatre (admission one penny), where dancing and singing take place every night. Crude pictures of the performers are arranged outside, to give the front a gaudy and attractive look, and at nighttime coloured lamps and transparencies are displayed to draw an audience."

Henry Mayhew, *London Labour and the London Poor,* 1859.

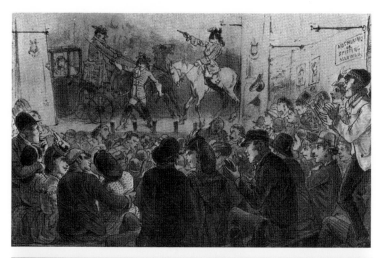

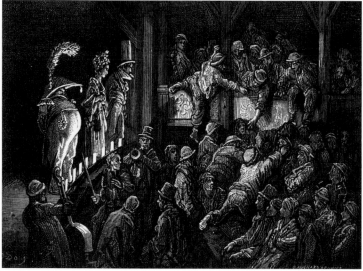

Previous pages
Production images during film shoot.

Top
James Greenwood,
Wilds of London, 1874.

Bottom
Gustave Doré and Jerrold Blanchard, *London,* 1872.

Opposite
Murray Melvin in *Oh What a Lovely War,* 1963.

"City based showmen around the country opened up what became known as 'Penny Gaffs', and sometimes in a more descriptive fashion, 'Flea-Pits', the names being an indication that moving pictures were still, in the early 1900s, regarded more as a diversion for the working classes than a pursuit of the bourgeoisie…. Pioneers quickly realised that they could put on film shows in whatever space was to hand…. Booths were set up in fairgrounds and markets. Within a very short space of time the booths became more elaborate and with the inclusion of organ music, dancing girls and MCs, the film show had inverted the Music Halls where they had got their start."

C Lee, *From Penny Gaffs to Electric Palaces*, 2005.

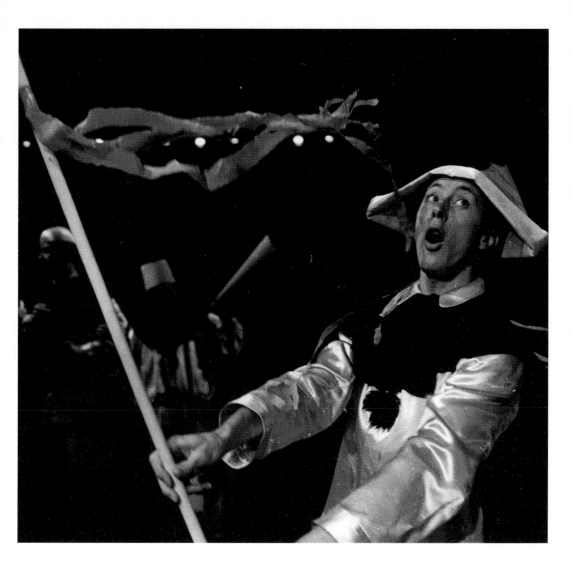

Goldsmiths MFA Art Writing

Timepieces, 2010
Publication, distributed at London Bridge Underground station

Julia Calver
Patrick Coyle
Cressida Kocienski
Claire Nichols
Tamarin Norwood
Gemma Sharpe

Timepieces is a collection of writing by six artists and writers in response to the Jubilee line. At the time of writing, each participant was studying on the MFA Art Writing postgraduate programme at Goldsmiths, University of London, which debates and enacts the diverse intersections between contemporary writing and art. The project was the outcome of a series of discussions between Maria Fusco, Director of MFA Art Writing, Goldsmiths and Art on the Underground about how contemporary art writing might be explored in the context of London Underground.

The result was *Timepieces*, a collection of writing and drawings brought together in a booklet and circulated to customers at London Bridge Underground station, so that they could be read underground, in the context in which they were conceived.

MFA Art Writing at Goldsmiths, University of London is a postgraduate programme addressing writing as art, art as writing, and writing through art, directed by Maria Fusco. The programme does not take modalities of writing as given, but tends to, and experiments with, non-division between practice and theory, criticism and creativity, identifying an approach within contemporary culture that, in seeking new potentials, embraces writing as a problematisation of the object of art, its dissemination and forms of exhibition.

Julia Calver looked over passengers' shoulders and read lines from their books. She imagined the objects from these passages speeding along the Jubilee line as though it were a wormhole for time travel through outer space.
Patrick Coyle scrambled familiar London Underground announcements and instructions, spelling out improbable stories and making surprising associations.
Cressida Kocienski traced the route of the Jubilee line above ground on foot, photographing the objects she found along the way, which she has described as imaginary instruments for measuring time.

Claire Nichols focused on architectural details and signs at London Bridge Underground station. Her drawings transfer these shapes in space onto shapes on paper.
Tamarin Norwood watched passengers passing time on their journeys and rewrote their actions as suggestions for other commuters.
Gemma Sharpe made a number of night-time journeys above ground from London Bridge station after the last Tube. Her text takes the form of a correspondence in which she meditates on the images, thoughts, movements and sounds evoked through such journeys.

Opposite
Claire Nichols, from the series
The Tacit Knowledge of the Underground, 2010.

Ways to Keep Time on the Jubilee line

- You can be looking up from your book
- You can kick your leg slowly twice to straighten a fold in your trousers
- You can have a side parting
- Your pushchair can have the wheel lock on
- You can unfurl a sandwich from foil and press the corners of it without looking up
- You can sometimes sniff
- You can be in your teens and keep your eyes almost closed but still sometimes blink
- Your eyebrows can be raised
- You can put your papers back in their plastic file
- You can try out positions for your lips around a sweet in your mouth
- Some of your shopping can roll out of your bag
- You can have a black parka on, with the bottom of it crumpled up to the right
- You can pivot your foot
- Your head can nod up and down while you sleep
- You can be sharing a bunch of closed lilies and holding hands
- You can have earphones on
- You can close your eyes
- You can have grey stripes on your scarf and yawn in the shape of a star
- You can breathe out through your nose
- Your suitcase can sometimes lean against the backs of your knees
- You can suddenly check for something in your plastic bag
- You can be a cellophane wrapper and slide the length of the platform floor in the breeze
- You can tap a rhythm on your pocket with your little finger
- You can rub your left eye
- You can make popping sounds with your lips, and then after a while you can yawn
- You can look to the right with a blue baseball cap on
- You can wear leather boots with sensible heels and look straight ahead
- You can furrow your brow and check your fingernails
- You can fold over the corners of your crisp packet one by one
- You can bunch up your lips
- You can make an oval yawn and scratch the side of your nose with your little finger
- You can have upright hair and keep an eye on your bag
- The lace in your shoe can come undone

Afterwards

Reviewing your recent letter to The Editor, I felt compelled to express my concerns with your argument. [1st: I had thought that at this time of night London would be quietened, but tonight it was not so. The last trains with their consignments of commuters were now moving outwards from the city's middle, retiring into the furthest and quietest zones of the metropolis until tomorrow. But the streets were not ready to sleep. Pedestrians were still walking over London Bridge with animation and conviction and that Wednesday night did not hold the energy of weary journeying.] ***You suggest that the recent financial report and the curtailment of your former privileges will discourage other women from seeking nomination.*** [2nd: A businessman was fixing his bike on the bridge. It lay distorted with its wheels pointing skyward as he rearranged its essential mechanics. He was performing a kind of secretive surgery that was no doubt tiresome for both. It was late and without such delicate operations conducted halfway across London Bridge, one of the two would have been left chained to a post for the night as the other climbed lonely onto a night bus, conspicuous in lycra.] ***You outline the shift-based nature of your routine and the necessary hours expected from your post. You describe the late journeys that you would now be making.*** [3rd: The evening's conversation remained audible like a tinnitus. I had been reading ghost stories in the day and there was a sallow agitation in the air, perhaps due to the forceful energy of the Thames that evening, raging at its high-tide dilation.] ***I suggest that tomorrow you miss your last train home and make that journey anyway.*** [4th: Getting onto the bus having walked again over London Bridge after the last Jubilee line train had passed on its way east, there was an uneasy sense of mutual co-option taking place among the bodies on that vehicle. They were a daunting assembly without even realising it.] ***I would be very interested to hear about the assorted discoveries that you make.*** [5th: I had thought that this late journey after deliberately missing the last train would be a haul, but with a few steps over the bridge there is an eight-wheeled route that takes me directly home. And so it seems that this residency at London Bridge station has more to do with London Bridge the Thames-straddler after which the station is named, than the station itself. Coming above ground to make my way train-less home, it is the habitual crossing of this monument towards Monument that has moved the pattern of my words.] ***Yours, exasperated, etc.***

Patrick
One
De

This station is Old St
Please stand back from the platform edge
Change here for Moorfields Eye Hospital
and mainline suburban rail services
The next station is Bank
This train terminates
Continue your journey from
London Bridge
Lift
Jubilee line
PLEASE MIND THE GAP
Help point
No smoking
The next station is Southwark
Keep clear
Destination: Stratford
Fire exits
STOP push
Penalty for improper use
Do not take any risks
Bermondsey
In an emergency
This train terminates at Stanmore
Passenger emergency alarm
This train terminates at Stratford
Jubilee line eastbound platform

This old Saint at the station,

pleased to be standing back in platform wedges.

"Change what you hear for more fields, I hope!

And real sirs mainly sup bourbon on ice.

The next pirate station of bankers

that train termites.

Sea on tin, you win. George's yearning form

is falling down.

Going up, when up is dn.

Julie, be mine!"

Please gap the mind.

He'll point,

but no one's mocking

the next Saint to walk the south of the ark.

"Key player

destined for Stratocasters and Fords."

Twelve ferets,

push pots

and a penchant for being improsperous.

"Do not take any skis

to Birmingham-on-Sea!"

Inanimate, you see.

This termite trainer can't stand anymore

massaging of the regency arm,

training termites to play guitars and drive cars.

Julie made a beeline east, bound in platforms.

Public Programmes

People, Place and the Interpretation of Time
Royal Observatory Greenwich
23 March 2010

One Thing Leads To Another—Everything Is Connected
London Journeys—Public Discussions
City Hall
14 May–10 June 2010

A series of public discussions and an exhibition in City Hall were conceived in collaboration with colleagues at the Greater London Authority, Royal Museums Greenwich and the Science Museum, London, to compliment the commissioned artworks and to provide further opportunities to explore ideas pertinent to time and travel in the Capital. Set within two iconic London buildings, diverse voices from a range of specialist fields proffered unique insights into these subjects.

The Royal Observatory Greenwich, home of Greenwich Mean Time, sits upon a hill south of the Thames, opposite Canary Wharf. Three factors have influenced the shape and growth of London and connect these two seemingly contrasting riverside landmarks: time-keeping, transport and trade. The Observatory provided the back drop to a lively discussion with Jonathan Betts, Senior Curator of Horology, Richard Dunn, Curator of Navigation and artists Goodwin and Gerrard, chaired by Richard Johns, Curator of Drawings and Prints that explored how time is measured.

To accompany the exhibition at City Hall, David Rooney, Curator of Transport, Science Museum chaired a two-part public event that brought together historians, geographers, design specialists and some of the commissioned artists.

London Journeys Underground explored people's experiences of travel undergroundÐhow do we navigate this alien environment and what tools do we employ to represent this experience to others? Speakers were Dr David Lawrence, Head of 3D Design, Kingston University, Iain Houston, Senior Planner, LU planning, and artist Dryden Goodwin.

The role of time in our city was considered in *London Journeys in Time*—what pressure does it create and how do we endeavour to escape or control it? Speakers were Prof Joe Kerr, Head of Critical and Historical Studies, Royal College of Art, John Law, historical geographer and artist John Gerrard. These discussions are available on the Art on the Underground website.

1 In the late nineteenth century, 72 per cent of the world's commerce depended on sea-charts which used Greenwich as the Prime Meridian. This was one of the reasons why Greenwich has served as the reference line for Greenwich Mean Time (GMT). For further information visit www.rmg.co.uk.

Top
One Thing Leads to Another—
Everything Is Connected, May 2010.
Exhibition at City Hall.

Bottom
London Journeys Underground,
public discussion at City Hall
with Dryden Goodwin, David
Rooney, David Lawrence and
Iain Houston.

Acknowledgments

Artists
Special thanks to the artists and writers for their dedication, vision and commitment in realising this ambitious and engaging series of projects in the ever-challenging context of London Underground.

Book
Thanks to Simon Elliot, Garry Blackburn, Rupert Gowar-Cliffe and Maja Hakenstad at Rose for their wonderful vision and sensitive approach to this publication and the projects overall, resulting in award-winning design.

Thanks to Matthew Stadler, writer, editor and publisher for his story text and to David Rooney, Curator of Transport, Science Museum, for his illuminating essay and for his generosity, expertise and contribution to the public discussions.

Projects
All our projects are realised thanks to the generosity and efforts of a great many people. Thanks to the Jubilee line staff for their invaluable contributions, energy and generosity towards each project: especially those who participated in Linear. Art on the Underground also wishes to thank Kevin Bootle, Line General Manager of the Jubilee line, and Dominic Paul and Tunde Alaoye, Performance Managers, for their unfailing support throughout this series. Thanks to our colleagues across London Underground and TfL for offering their time and expertise to this series.

We are very grateful to all participants and collaborative organisations:

Jubilee line customers daydream survey
Carol Seigel, Ivan Ward, Freud Museum; Susanna Chisholm, Maureen Paley, Maureen Paley, London; Benedict Johnson.

Linear
Jo Cole-Goodwin; Prudence Cumming; London Transport Museum; Anna Chinsk, John DiMaggio, Chris McKeeman, Nicespots; Ray Stevens.

Oil Stick Work
(Angelo Martinez/Richfield, Kansas)
Martine d'Anglejan-Chatillon, Thomas Dane and Tom Dingle, Thomas Dane Gallery; Robin Evans, XL Events; Gordon Gibson, Tube Lines; Helmut Bressler; Daniel Fellsner; Angelo Martinez; Werner Poetzelberger; Matthias Strohmaier; Jakob Illera, Inseq Design.

One thing leads to another—Everything is connected
Fraser Muggeridge, Sarah Newitt, Fraser Muggeridge studio; Clarrie Wallis, Tate Britain.

Threads
Lorenzo Belenguer, Bar Gallery; Denise, Mohammad, Monika Hrubecka, Nicole Rush, James Salter and all the young people from Brent Youth Inclusion Programme, Brent Youth Services; Greygory Vass, Camden Arts Centre; Janice McLaren, The Photographer's Gallery; Wayne Smith, Wembley Stadium.

Timepieces
Maria Fusco, Goldsmiths University.

**The Stratford Gaff: A Serio-Comick-
Bombastick-Operatick Interlude**
Alex Baker, Tom Richards, ADi Audiovisual; Nadia
Bettega; Elaine Elliott; Joanne Hayes, Brick Lane
Music Hall; Lola Gibbard; Jenny Beeching, Forest
Roots; London Sri Murugan Temple; Kitty Monroe;
John Munday; Shafique Khan, Newham Academy
of Music; Sujata and Tari Sian, Nusound 92FM;
Carole Jolly, The Pearly Kings & Queens Society;
Lakmini Shah; Gary Wilson, Stratford Circus;
Jenni Munro-Collins, Heritage and Archives
Search Room, Stratford Library; Shara Brice, The
Ascension Eagles; Karen Fisher, Murray Melvin,
Theatre Royal Stratford East; Roy Thomas.

The performers: Chantal McNeish, Patrick
Asante, Jason O'Shea, Conor Kenny, Oishin
Lastrollo, The Ascension Eagles; Viktor Obsust,
Tiago Alves, David Shulman, Zac Gvurtzman,
Ben Czureja, Aven Romale; George Davison,
Doreen Golding, Arthur Rackley, John Scott, John
Walters, The Pearly Kings & Queens Society; Larry
Barnes; Victoria Elizabeth Day; Dizzle Kid; Mr K,
Kali and Bhanu Kanthagnany; Murray Melvin; Sovra
Newman; Charlie Seber; Mangal Singh.

Crew, production and post-production: Alex
Bennett; Deborah Bullen; Ross Birkbeck; Peter
Brimson; Mick Duffield; Rob Entwistle; Domenico
Favata; Cath Hawes; Doug Hayward; Katy
Howkins; Nela Hecht; Enfys Hughes; Cristina
Monce; Mattias Nyberg; Chin Okoronkwo; Terry
Robb; Roger Sabharwal; Andy Sauer; Natasha
Theobald; Kelly Stewart.

Public Programmes
Munira Mirza, Justine Simons and the Culture
team, Greater London Authority; Chris Deakin;
Sam Forster; Iain Houston; Joe Kerr; John Law;
David Lawrence; Mark Wayman; Jonathan Betts,
Richard Dunn, Richard Johns, Louise Simkiss,
Royal Museums Greenwich.

Photographers Alastair Fyfe, Daisy Hutchison,
Andy Keate.

Team
Rebecca Bell, Steve Catanach, Louise Coysh,
Tamsin Dillon, Josephine Martin, Sally Shaw,
Nick Triviais.

Funders
Jo Baxendale, Julie Lomax, Lee Milne, Arts
Council England.

A MAN OHE